Toulouse

Lautrec

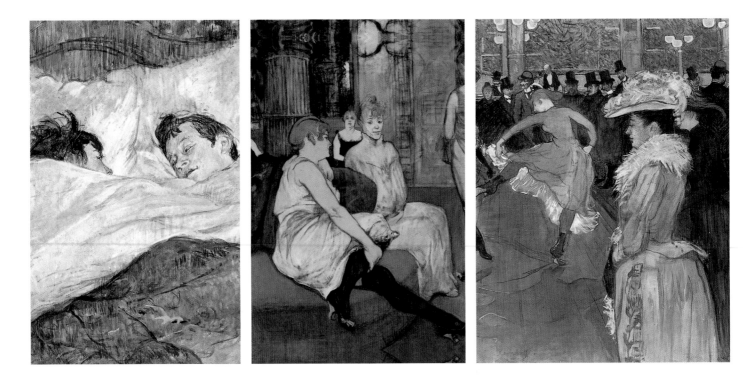

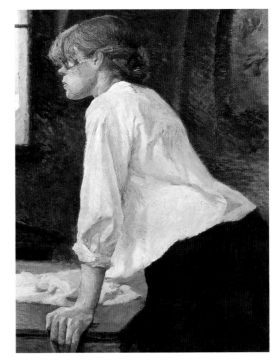

© Confidential Concepts, worldwide, USA, 2004
© Sirrocco, London, 2004 (English version)

Published in 2004 by Grange Books
an imprint of Grange Books Plc
The Grange Kingsnorth Industrial Estate
Hoo, nr Rochester Kent ME3 9ND
www.Grangebooks.co.uk
ISBN 1-84013-658-8
Printed in China

Toulouse

Lautrec

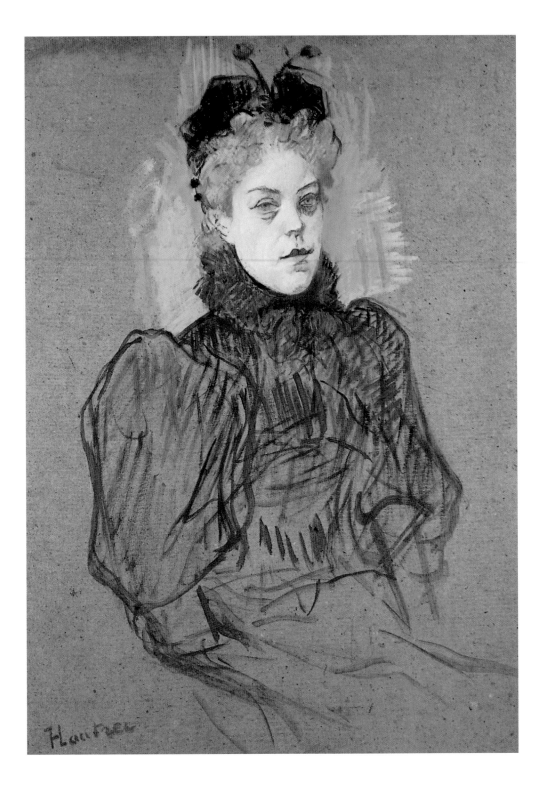

'You know, if one were a Frenchman, or dead, or a pervert - best of all, a dead French pervert - it might be possible to enjoy life!' laments a frustrated and unsuccessful artist in an illustration in the German satirical magazine *Simplicissimus* issued in 1910. He is endeavouring to paint while his domestic life crowds in on him from every direction: children run about screaming, toys lie scattered on the floor, and his wife is hanging up washing on a line stretched across his studio. The idea that genius and domesticity are incompatible with one another was hardly new, but the artist's comment shows how quickly the turbulent lives and premature deaths of Henri de Toulouse-Lautrec and Paul Gauguin had entered popular mythology. Lautrec, who died aged thirty-seven in 1901, Gauguin, who died aged fifty-five in 1903, and the Dutch-born but French-by-adoption Vincent van Gogh did more than any others to colour popular ideas about the 'artist' in the twentieth century.

Although the notion of the artist as a self-destructive outsider reached its peak at the end of the nineteenth century with Lautrec, Gauguin and van Gogh, its origin can be traced back to the late eighteenth century when political, cultural and economic revolutions transformed the way artists saw themselves and their relations with the world around them. In 1765, under the *ancien régime*, the pastel artist Maurice Quentin de La Tour depicted himself as an aspiring courtier, with powdered wig, velvet jacket and an ingratiating smile.

Somewhat less pretentiously and dressed a good deal more practically, his contemporary Jean-Baptiste Siméon Chardin also showed himself as a well-adjusted and contented member of society on a lower social rung. Two or three decades later, the smiles and benign expressions no longer appear on the faces of a new generation of young artists including Jacques-Louis David, Henry Fuseli and Joseph Turner. These are young men in complex and even tormented states of mind, whose self-portraits challenge the viewer with their ferocious stares.

A link between the angry young men of Romanticism and the *peintres maudits* of the late nineteenth century is provided by Gustave Courbet who in the 1840s and 50s developed the myth of the artist as outsider in a series of self-portraits culminating in the famous *Bonjour M. Courbet*.

1. *May Milton*, 1895. Oil and pastel on cardboard, 65.9 x 49.2 cm. The Art Institut of Chicago, bequest of Mrs Kate L. Brewster.

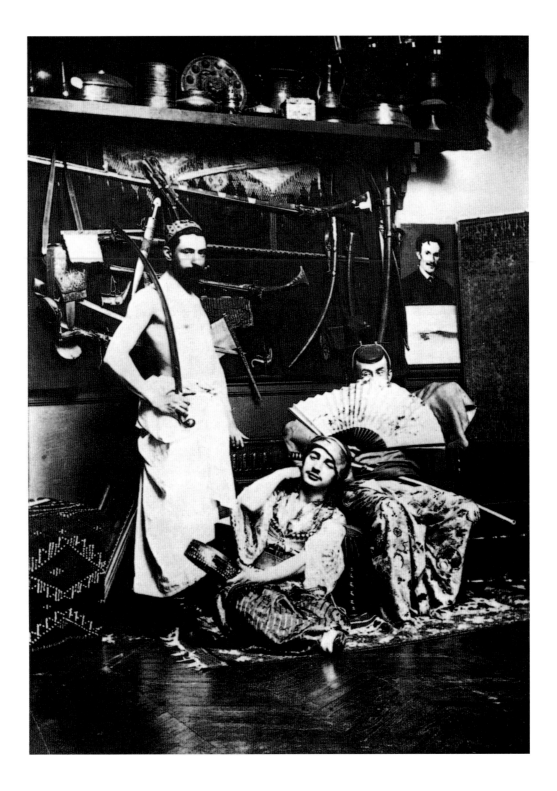

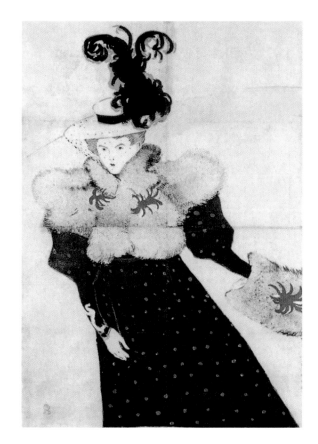

In this painting, Courbet flouts social conventions with his bohemian appearance and his lordly body language as he greets his wealthy bourgeois patron. Lautrec, too, relished in the role of bohemian outsider, and celebrated it in a series of elaborately-posed group photographs of himself and his friends in outrageous fancy-dress costumes. Most hilariously, in 1884 he painted a parody of Pierre Puvis de Chavannes' noble masterpiece *The Sacred Grove Cherished by the Arts and Muses* in which he shows himself and his drunken friends bursting precipitately into the sacred grove. He emphasises his own grotesque and dwarf-like appearance. Seen from behind, he seems to be urinating in front of Puvis' solemn ladies.

Lautrec also played a significant role in developing another great cultural myth - that of 'Gai Paris', of Paris as the capital of nocturnal and illicit pleasures. This myth is most powerfully evoked by Lautrec's 1891 poster for the Moulin Rouge and also of course by the famous galop infernal or can-can from Offenbach's operetta *Orpheus in the Underworld*.

2. Lautrec with his
 friends Claudon and
 Nussez in oriental
 fancy dress, ca. 1884.
 Photography.

3. *La Revue Blanche*,
 1895. Colour lithograph,
 poster, 125.5 x 91.2 cm.

But to mention Lautrec and Offenbach together highlights a significant difference between the two, highlights another aspect of the myth surrounding Toulouse-Lautrec: his highly perceptible decadence. The Second Empire hedonism of Offenbach is vigorous, earthy and gloriously vulgar. Lautrec's fin-de-siècle hedonism is more refined and contains an element of self-conscious decadence and perversity. It was partly Lautrec's physical infirmities that made him seem - along with the tubercular Aubrey Beardsley - so representative of fin-de-siècle decadence. For the francophile German critic Julius Meier-Graefe, who did much to promote Lautrec's international reputation in the 1890s, Lautrec's art expressed the decadence of France and of the Latin races. In 1899, he wrote: 'France, the lovely, unlucky land, is today like a ruined ballroom, in which the vilest crimes and the most heroic deeds are committed side by side, by almost the same men. Already the ballroom burns on all sides, and within it the muse of Lautrec dances, with astounding agility, the last diabolical can-can.'

Henri Marie Raymond de Toulouse-Lautrec was born in 1864 in Albi, in south-western France, into a wealthy and distinguished noble family that could trace its lineage back to the time of the crusades. Lautrec's father was eccentric and neglectful. His pious and over-protective mother has been criticised for the way in which she later handled his illness.

However, correspondence still extant shows that they were a close and loving family. The young Henri was cherished and spoilt. One of his grandmothers wrote of him, 'Henri keeps chirping from morning to night. He goes on like a cricket who brightens up the whole house. His departure leaves a great gap each time, for he really occupies the place of twenty people here.'

Before the twentieth century when such things ceased to matter, Lautrec was unique among the great European painters in coming from such a privileged and aristocratic background. It is worth remembering that the great French cultural flowering that illuminated the world throughout the nineteenth century was very largely the product of one class - the much-maligned bourgeoisie. Very few French artists of any significance came from either the working classes or from the aristocracy. The young Henri was encouraged to draw and paint, and was praised for his precocious efforts. Like women, aristocrats were expected never to advance beyond the stage of the gifted amateur. (One is reminded of the Morisot sisters, whose art teacher warned their parents that they were in danger of becoming too skilled for their own good.) Lautrec himself would probably never have progressed beyond the amateur had it not been for two accidents in his early teens.

4. *Parody of Puvis de Chavannes "The Sacred Wood"*, 1884. Oil on canvas, 172 x 380 cm. The Henry and Rose Pearlman Collection.

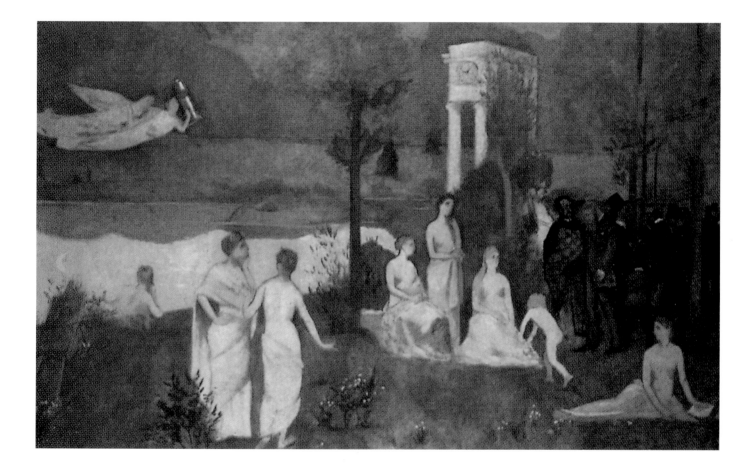

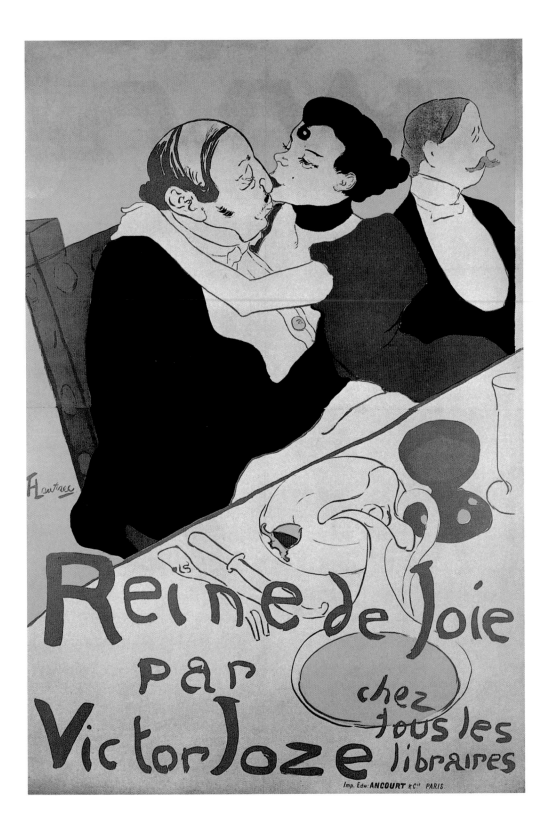

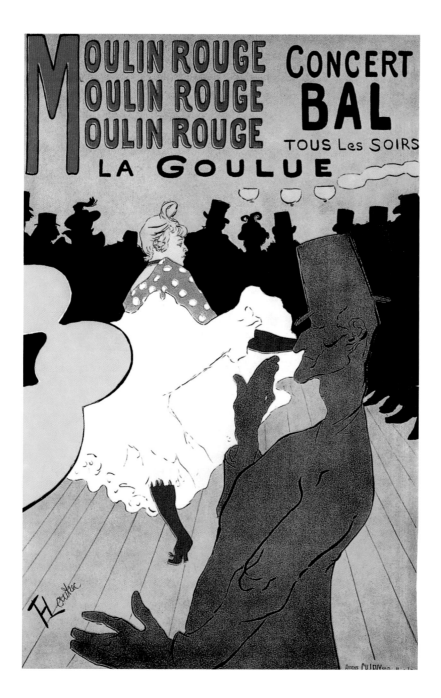

5. *Reine de joie.*
 (Queen of Joy), 1892.
 Lithograph in four
 colours, poster,
 136.5 x 93.3 cm.
 Musée Toulouse-
 Lautrec, Albi.

6. *Moulin-Rouge,*
 la Goulue, 1891.
 Colour lithograph,
 poster, 191 x 115 cm.

Perhaps as a result of inbreeding (his parents were first cousins and his grandmothers were sisters), Lautrec's young bones failed to heal properly and his legs ceased to grow, leaving him stunted, deformed and quite literally déclassé. He could no longer follow the traditional outdoor pastimes of his class - notably hunting.

At the age of seventeen, having scraped through his baccalauréat at the second attempt, and because a legal or academic career was hardly an option, Lautrec was allowed to study art more seriously. After a brief period in the studio of a minor artist called René Princeteau, who specialised in painting horses (Lautrec was never to lose his aristocratic enthusiasm for horse-meat), Lautrec then went on, rather conventionally for him, to study with two of the most admired academic painters of the day, Léon Bonnat and Fernand Cormon. Cormon seems to have been Lautrec's own choice. In a letter to his father in 1882, Lautrec described Cormon as 'a powerful, austere and original talent'.

To modern eyes, it must be said, Cormon's vast reconstructions of stone-age life look ludicrously theatrical and pompous. His stone-age women comport themselves with an unmistakable air of Parisian chic, and their elegant contours evidently owe more to the corset-maker's art than to nature. Lautrec was not a particularly successful student. Bonnat was forthright with him: 'Your painting is not bad. It's perhaps a bit too modish - still, it's not bad. But your drawing is truly atrocious.' Lautrec's time in the studios of Bonnat and Cormon had the advantage of introducing him to the nude as a subject. Life-drawing of the nude was the basis of all academic art training in nineteenth century Paris. Nude drawings and paintings by Lautrec in the 1880s show clearly enough what it was that so offended his teacher Bonnat. *The Nude Study* of 1883 (p.15) and *Voluptuous Mary* of 1885 (p.18) - both executed while Lautrec was still working with Cormon - are academic nude studies of a type Lautrec would rarely produce later on. The women each pose motionlessly in what seems to be an artist's studio. A piquant touch of modernity is given to the earlier nude by her black shoes and stockings. Her pose suggests loneliness and vulnerability - themes that Lautrec would explore later in many of his brothel pictures.

In neither case did Lautrec follow the academic practice of correcting the proportions and improving the appearance of his models. *Voluptuous Mary* (p.18) in particular has a body of squat proportions and somewhat coarse facial features. (She would make a far more convincing cave-woman than any painted by Cormon.)

7. ***Debauchery***, 1896. Pen and dark brown ink on white paper, 16.8 x 11.3 cm. Private Collection.

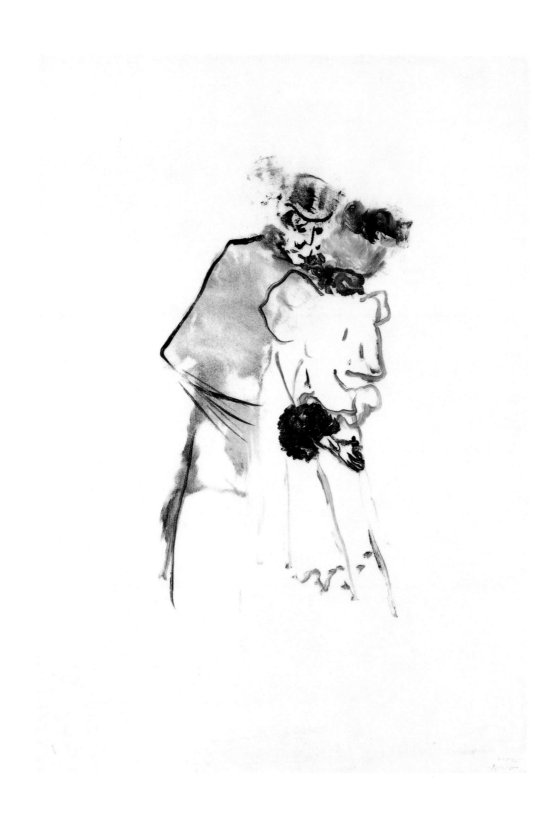

8. **Conversation**, 1899.
 Monotype in oils on
 white paper,
 49.5 x 35.5 cm.
 Private Collection.

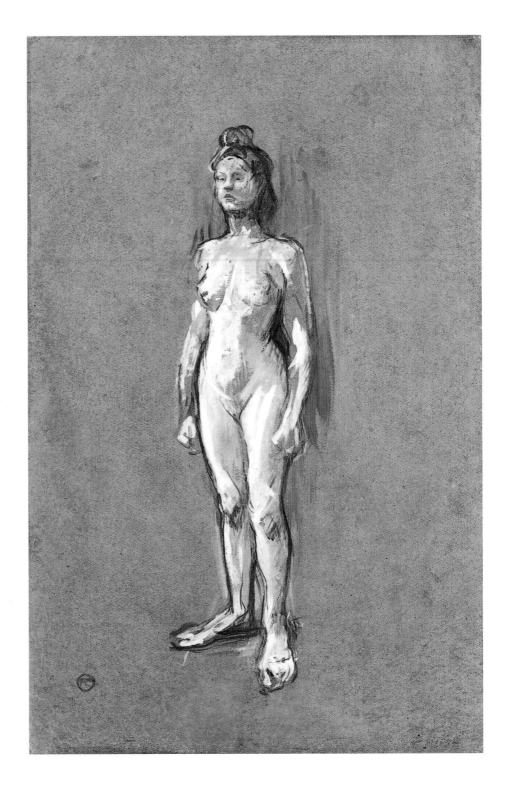

9. **Standing Female Nude**, *frontal view*, 1898. Oil on cardboard, 80 x 53 cm. Musée Toulouse-Lautrec, Albi.

10. **Nude Study**, 1883. Oil on canvas, 55 x 46 cm. Musée Toulouse-Lautrec, Albi.

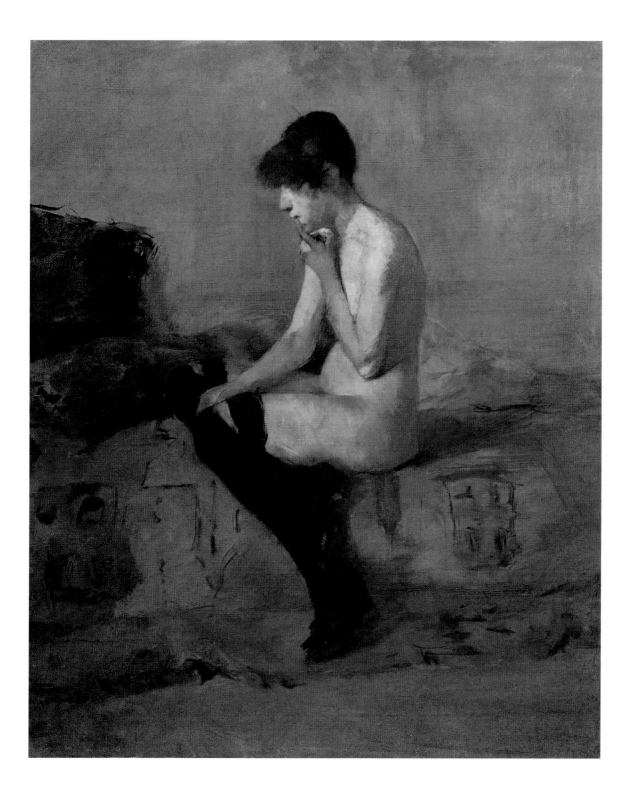

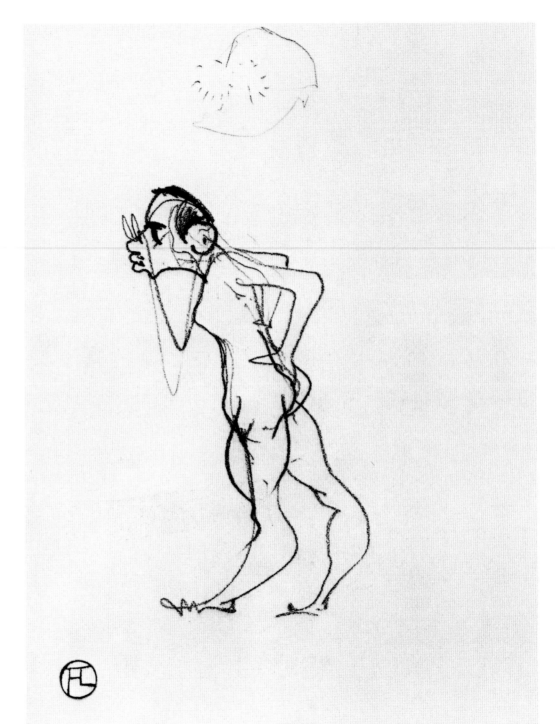

11. **Self-Caricature**, 1888.
Chalk on white paper,
25.5 x 16 cm.
Museum Boymans
van Beuningen,
Rotterdam.

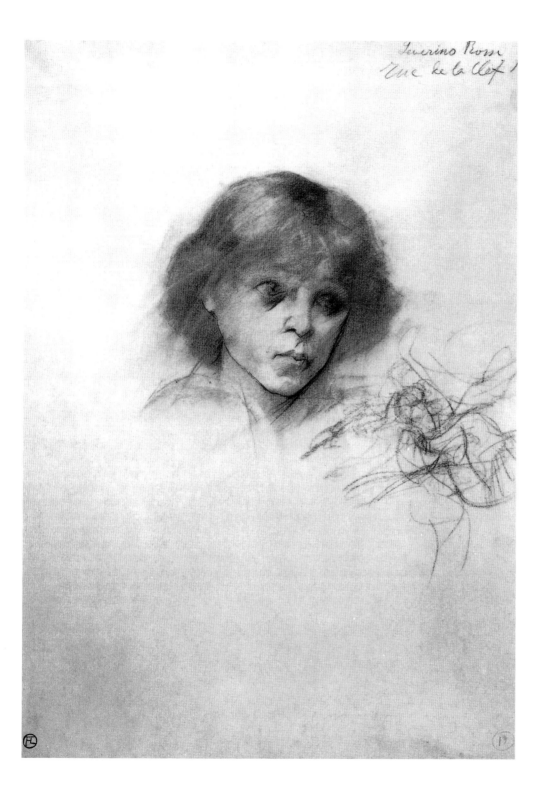

12. ***Child's Head,***
Severino Rossi, 1883.
Charcoal on white
paper,
62 x 47 cm.
Musée Toulouse-
Lautrec, Albi.

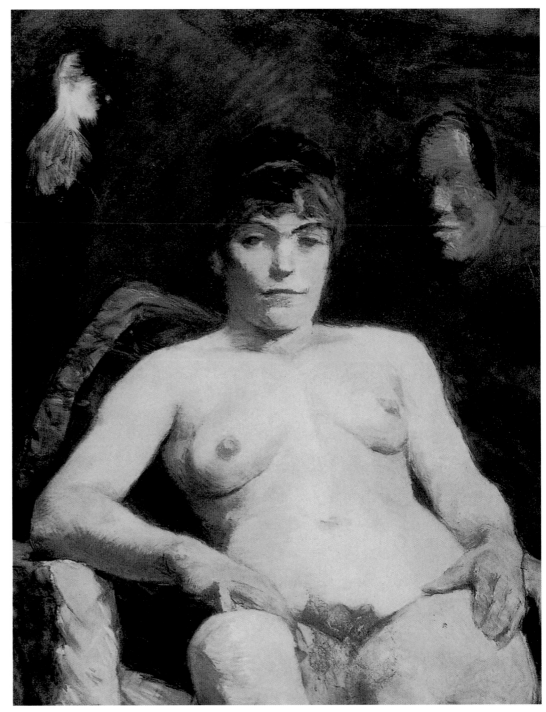

13. **Voluptuous Mary,
Venus of Montmartre**,
ca. 1885.
Oil on canvas,
80.7 x 64.8 cm.
Von der Heydt
Museum, Wuppertal.

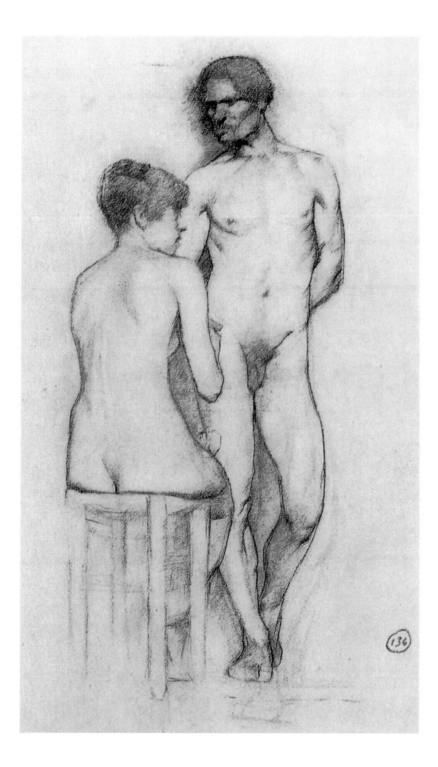

14. ***Nude Couple, Woman
Seated*** (Figure study),
1883-87.
Charcoal and graphite,
63 x 49 cm.
Musée Toulouse-
Lautrec, Albi.

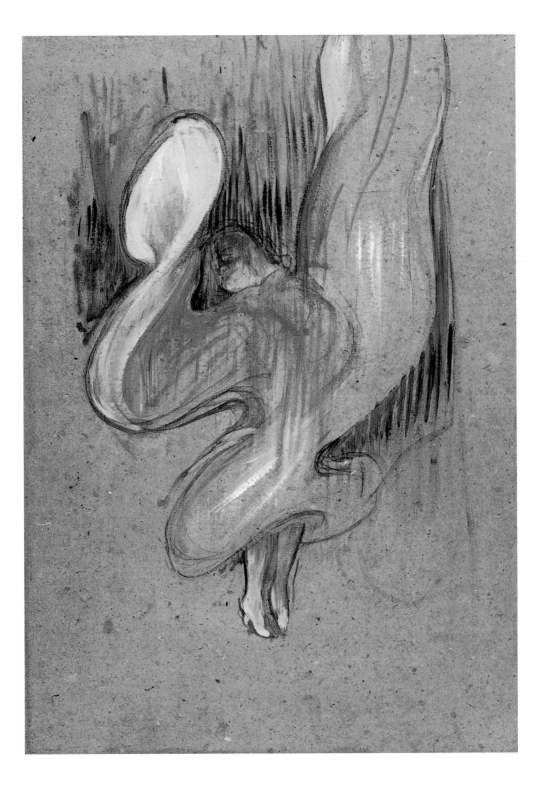

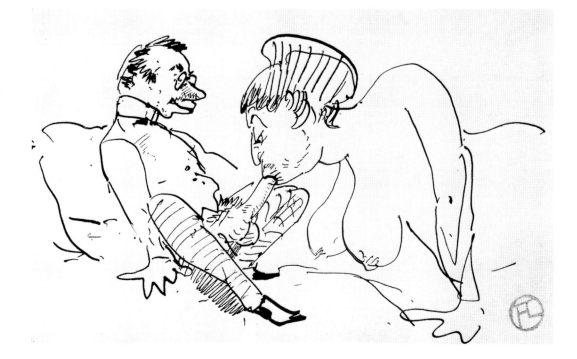

Her awkwardly foreshortened knees are parted to reveal a vigorous bush of dark pubic hair, a detail that would have been tactfully hidden or omitted with any conventional academic nude.

While still a student, Lautrec began the exploration of Parisian nightlife, which was to provide his greatest inspiration and eventually to undermine his health. In the early stages of this exploration, Lautrec was often accompanied and encouraged by a fellow student from Cormon's studio called René Grenier. For some time, Lautrec lodged with Grenier and his beautiful wife Lili. He clearly enjoyed a relaxed and somewhat unconventional relationship with the couple, at one stage drawing a pornographic caricature of Lili, nude and with huge pendulous breasts hanging over the diminutive and almost fully dressed Lautrec as she performs fellatio on him.

Lautrec was one of those artists able to stamp their vision of the age in which they lived upon the imagination of future generations. Just as we see the English court of Charles I through the eyes of van Dyck and the Paris of Louis-Philippe through the eyes of Daumier, so we see the Paris of the 1890s and its most colourful personalities through the eyes of Lautrec.

15. *Loïe Fuller at the Folies Bergère,* 1892-1893. Black chalk and oil on cardboard, 63.2 x 45.3 cm. Musée Toulouse-Lautrec, Albi.

16. *Caricature of Lautrec and Lili Grenier*, 1888. Pen and black ink on beige paper, 11.1 x 17.7 cm. Private Collection.

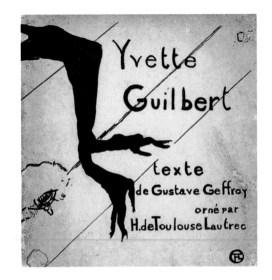

The first great personality of Parisian nightlife that Lautrec encountered - and a man who was to play an important role in helping Lautrec develop his artistic vision - was the cabaret singer Aristide Bruant. Bruant stood out as a heroic figure in what was the golden age of Parisian cabaret. His abrasive tones and mordantly irreverent wit can still be savoured in primitive recordings made shortly after the turn of the century. Lautrec delighted in the scurrilous insults with which Bruant taunted his audiences and in his jaunty and cynical songs of Parisian low-life such as *Nini peau de chien* ('Dog-skin Nini'). In turn, Bruant was one of the first to appreciate Lautrec's art, commissioning a poster which became an icon of Parisian cabaret.

Among the many performers inspiring Lautrec in the 1890s were the dancers La Goulue and Valentin-le-Desossé, who both appear in the famous Moulin Rouge poster, Jane Avril and Loïe Fuller, the singers Yvette Guilbert, May Belfort and Marcelle Lender, and the actress Réjane. Although some of these performed long enough to be recorded or even filmed, they owe their immortality to a lesser or greater extent to the brush and pen of Lautrec. The singer May Belfort, for example, would hardly be remembered if it were not for Lautrec's vivid images of her on stage.

Actually of Irish origin, May Belfort represented to Parisian audiences what they believed to be the stereotypical English girl: sexually repressed, but knowing. She appeared on stage as an English schoolgirl dressed in her nightcap and gown and singing in a girlish, piping voice 'I've got a little cat, and I'm very fond of that.'

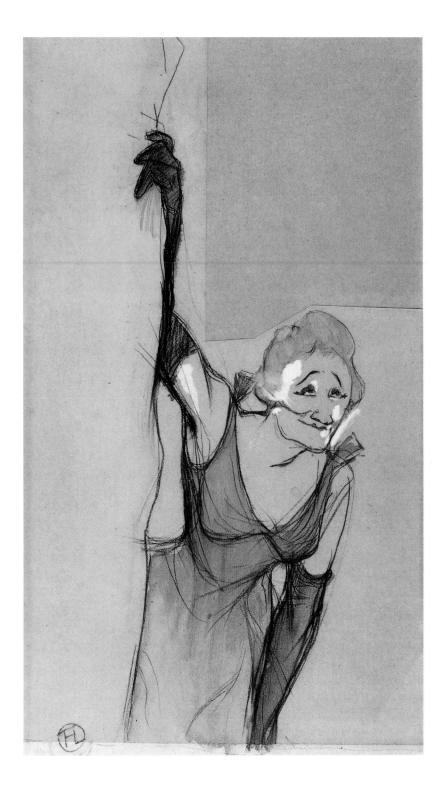

The little black pussy that she clutched in her arms meanwhile was no more than an excuse for the most outrageous sexual innuendoes. Manet had already exploited the sexual connotations of the black cat in his notorious *Olympia* three decades earlier.

To be immortalised by the merciless brush of Lautrec was a double-edged honour, as the cabaret singer Yvette Guilbert discovered. This great pretative artist, possessed of distinctively plangent tones and an incomparable ability to put across both naughty and poignant songs, was widely regarded as the voice of Paris. With her wide mouth and upturned nose, Yvette Guilbert was never a great beauty, but rather what the French term 'jolie-laide' (pretty-ugly). In his numerous depictions of Guilbert, Lautrec brilliantly captured her gestures and her knowing and lewd grimaces as she emphasised a risqué lyric, but he also cruelly exaggerated her slightly odd facial features and made her seem far older than she actually was. The pleasantly smiling young woman we see in contemporary photographs was transformed by Lautrec into a raddled, wizened hag.

Although Yvette Guilbert liked Lautrec and admired his art, she was unsurprisingly ambivalent about the images he made of her. On one of them she inscribed the message: 'Little monster! You have made a monstrosity of me!' Many of Lautrec's female subjects could have said the same. The ravishing operetta star Marcelle Lender was similarly aged and caricatured in a colour lithograph that caused a major scandal in Germany when it was published in the Berlin magazine *Pan* in 1895. Cruellest of all is the lithograph made in 1898 of the great actress Gabrielle Réjane in her most celebrated role, that of Madame Sans-Gène. Like so many female stage-performers of her day, Réjane had apparently once been involved in prostitution.

A 'Directory and Guide' to Parisian prostitutes produced in the 1880s for English-speaking visitors described her thus: 'Gabrielle was always a dirty-nosed, draggle-tailed little slut. Yet she succeeded in obtaining a second prize, in 1874, at the Conservatoire and was then engaged at the Vaudeville, where she now acts, and where her talent for mimicry is well received. She has had more lovers than she can remember . . .

Réjane is far from being pretty, but she has a kind of saucy charm about her that pleases many. She is thin and dark, with a crooked mouth, plain features, irregular teeth and plenty of brown hair. Her health is poor, in consequence of early indulgence in the art of love. Familiar with the sports of Sappho, she is not at all faithful to her keeper, and nothing is too shocking for her so she never refuses a pederastic challenge.

19. *Yvette Guilbert Greeting the Audience*, 1894. Chalkpen, watercolour, and oil on tracing paper stretched on cardboard, 41.6 x 22.8 cm. Museum of Art, Rhode Island School of Design, gift of Mrs. Murray S. Danforth.

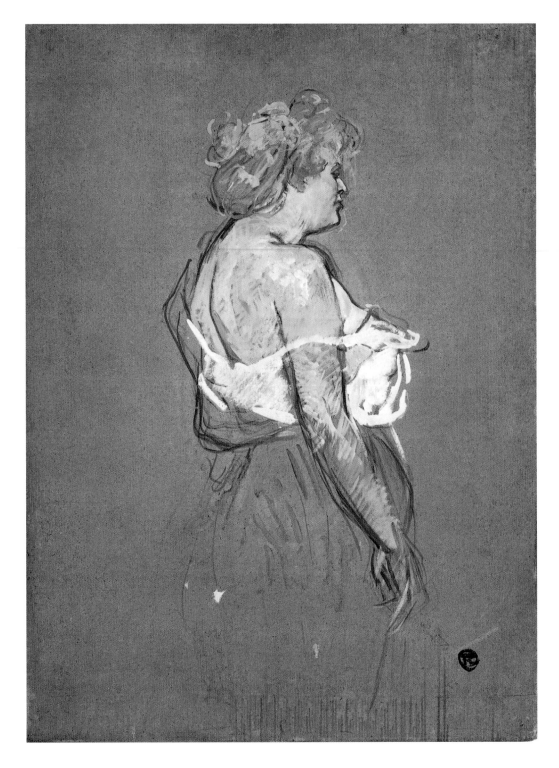

20. ***Miss Lucie Bellanger,***
 1896.
 Oil on cardboard,
 80.7 x 60 cm.
 Musée Toulouse-
 Lautrec, Albi.

21. ***Woman's Head,*** 1896.
 Black chalk and oil on
 cardboard,
 42 x 36 cm.
 Private Collection.

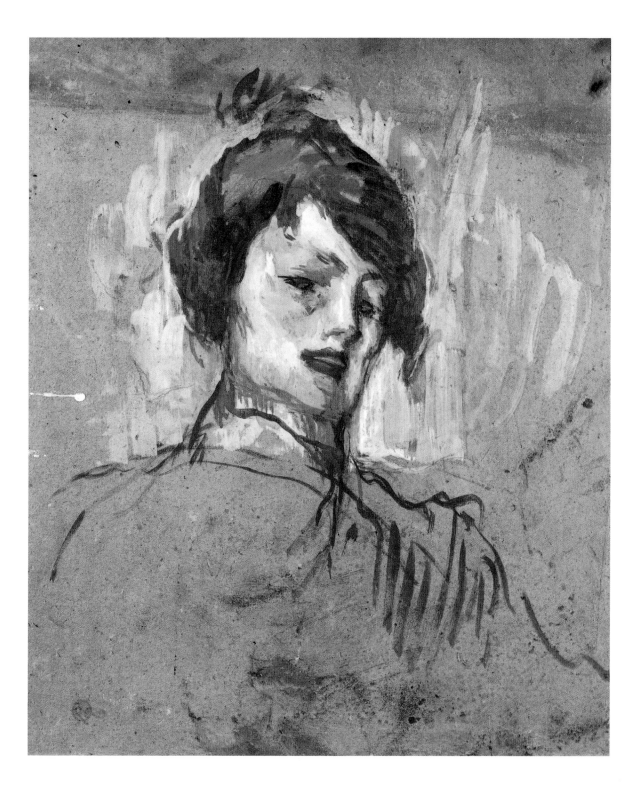

22. *Yvette Guilbert*,
 Study for a poster,
 1894. Charcoal,
 coloured ink,
 186 x 93 cm.
 Musée Toulouse-
 Lautrec, Albi.

23. *Jane Avril*, 1899
 Pencil on white paper,
 55.8 x 37.6 cm.
 Private Collection.

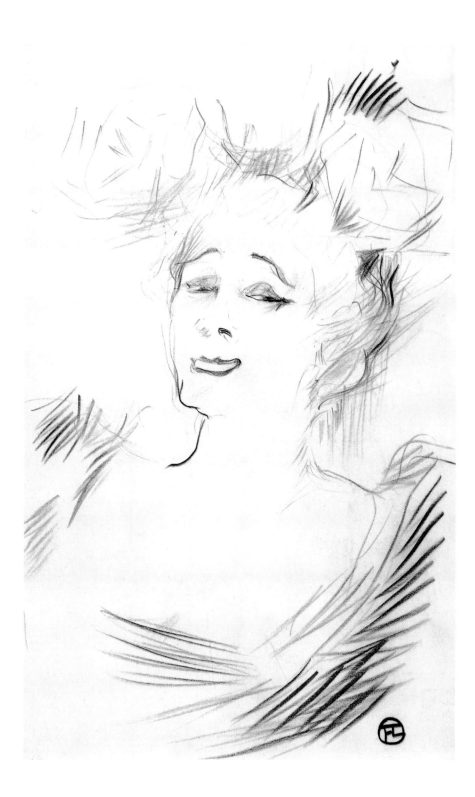

24. *Miss Marcelle
Lender*, 1895.
Black and blue chalk
on white paper,
30.2 x 19 cm.
Mr and Mrs Eugene
Victor Thaw,
New York.

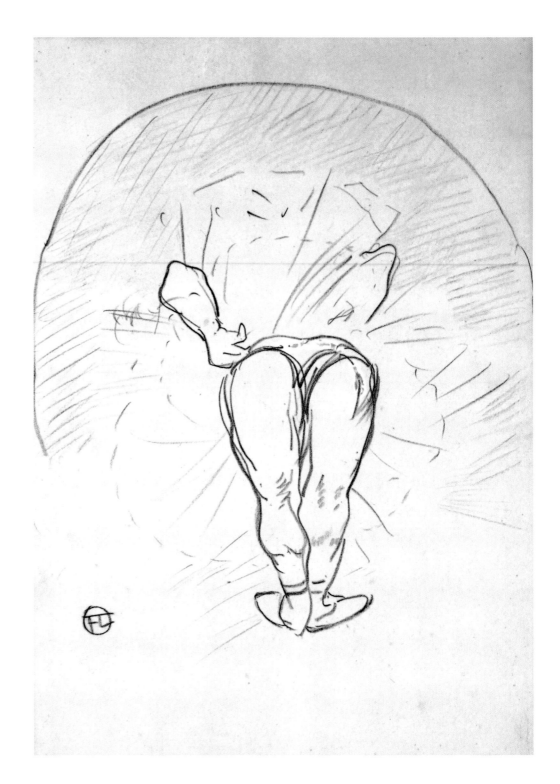

25. *Footit as a Ballerina*,
1894-1895.
Black and blue chalk,
with white wash on
white paper,
36 x 23.2 cm.
Private Collection.

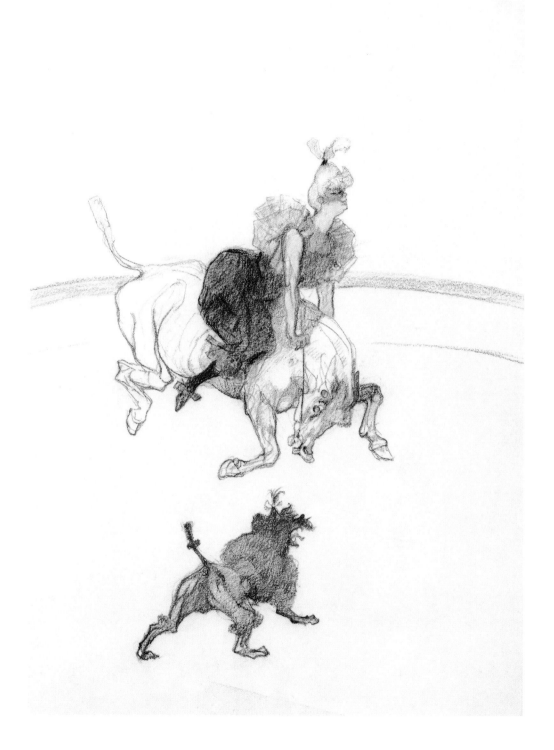

26. ***At the Circus***, ***the Female Clown***, 1899. Black chalk, colour crayons and pencil on paper, 35.6 x 25.4 cm. The Fogg Art Museum, Harvard University, bequest of Frances L. Hofer.

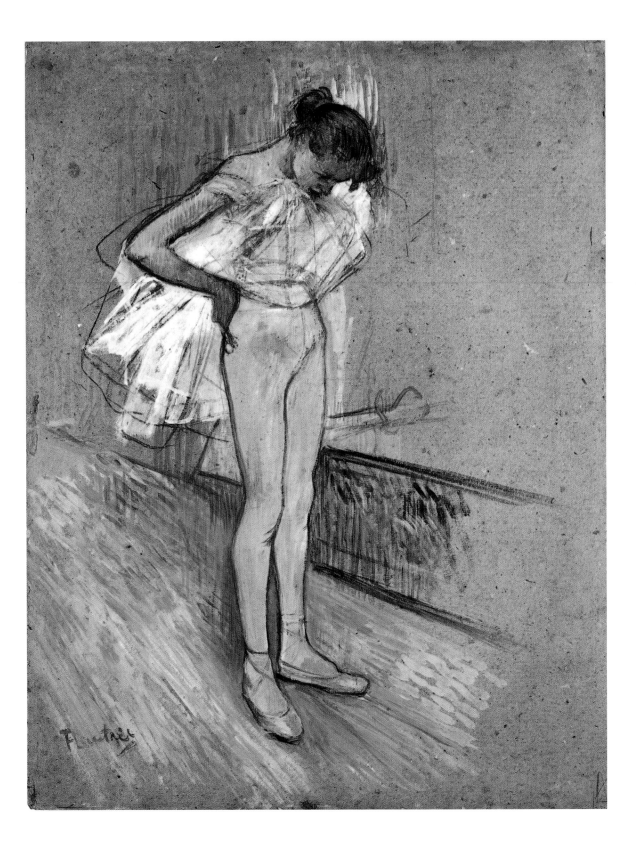

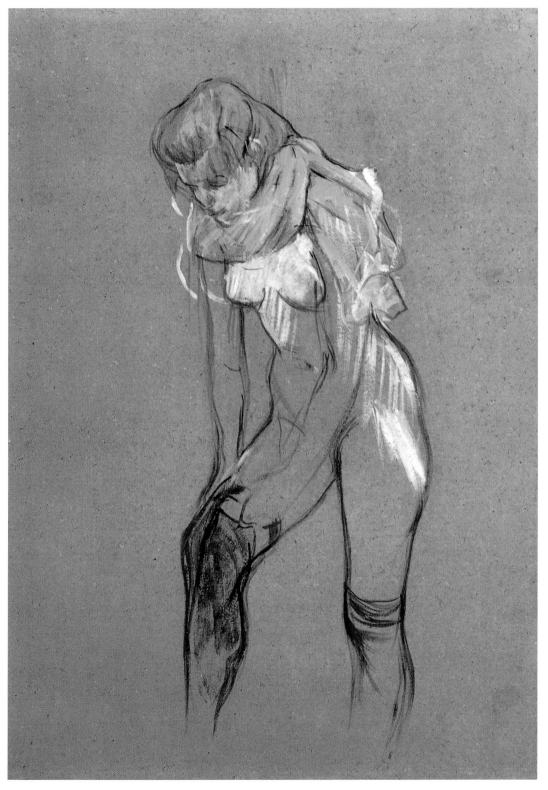

27. ***Dancer Adjusting her
 Tights or The First
 Pair of Tights,*** 1890.
 Black chalk and oil on
 cardboard, 59 x 46 cm.
 Private Collection.

28. ***Woman Adjusting her
 Garter*** (Study), 1894.
 Oil on cardboard,
 61.5 x 44.5 cm.
 Musée Toulouse-
 Lautrec, Albi.

In short, she is a shameless, intelligent, entertaining little monkey, who manages to please both male and female adorers.' In Lautrec's portrait it is as though he were trying to capture all of this at once. He reduces the charming and youthful face we see in photographs of the period to a leering mask of depravity.

The chalky complexions and thin vampire-like red lips of many of Lautrec's female portraits, such as the *Woman With the Feather Boa*, give them a sinister and unhealthy air. There is more than a hint of misogyny in many of Lautrec's depictions of women. In this, Lautrec has much in common with such contemporaries as Vallotton, Münch and Beardsley, not to mention the symbolist and Salon artists of a more literary bent, who loved to paint historical, mythical and literary femmes fatales.

One female performer depicted by Lautrec who escaped more lightly was the American dancer Loïe Fuller. She first appeared at the Folies Bergère in 1892 and reached the zenith of her fame during the 1900 Paris World Exhibition. Dubbed 'the electric fairy', she devised an act that exploited the effects of the newly-invented electric lighting as she leapt around waving vast sheets of material draped over long poles. The art nouveau swirls she created in her act appealed greatly to a number of contemporary artists. Realising that the novelty of electric lighting would eventually wear off, she begged Marie Curie to make her radioactive so that she would be able to glow in the dark without the aid of wires and plugs.

We can make a fascinating comparison between film footage of Loïe Fuller's performance and what Lautrec made of it. In this case, it is the camera that is the more merciless recorder of Loïe Fuller's plain and dumpy appearance and her lack of talent as a dancer. By means of an innovative graphic technique that involved the use of gold dust, Lautrec succeeds better in conveying the magic of her act, although the way he draws her stumpy little legs poking out from under her vertiginously floating veils shows that he was not blind to the more comical aspects of her performance.

If Lautrec's depictions of actresses and singers could be harsh, caricatural and even misogynist, his treatment of working-class women and prostitutes was often extraordinarily tender and sympathetic. In this, he differs greatly from his hero and mentor, Edgar Degas. The influence of Degas is all-pervasive in the art of Lautrec, both in terms of style and subject matter.

29. *Woman at her Toilette*, 1889.
Oil on cardboard,
45 x 54 cm.
Private Collection.

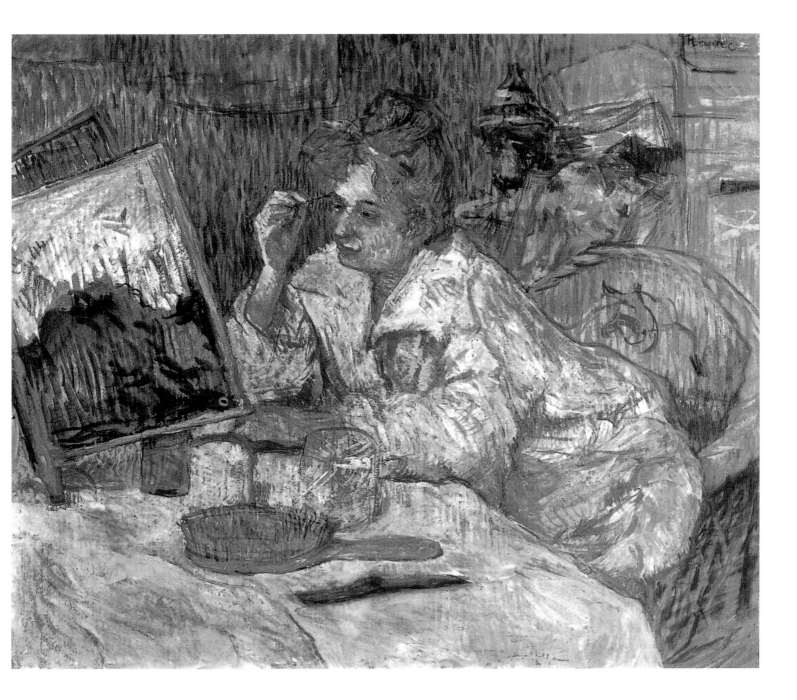

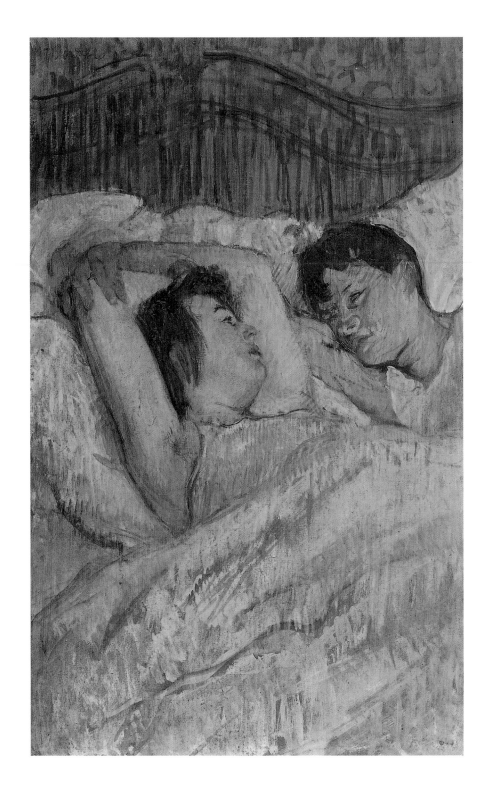

30. *In Bed*, 1892.
 Oil on cardboard,
 53 x 34 cm.
 E. G. Bührle Trust
 Collection, Zurich.

31. *Red-Haired Woman*
 Seated on a Divan,
 1897.
 Oil on cardboard,
 58.5 x 48 cm.
 Private Collection.

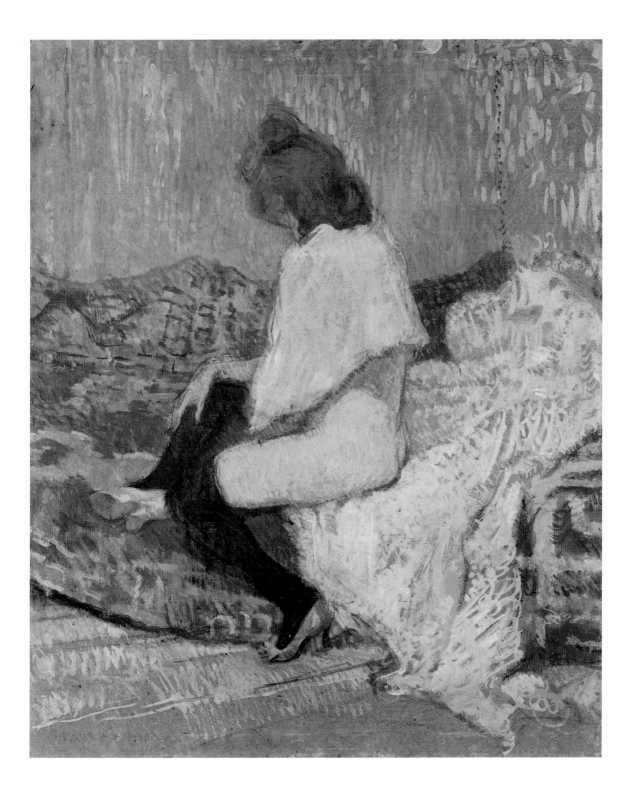

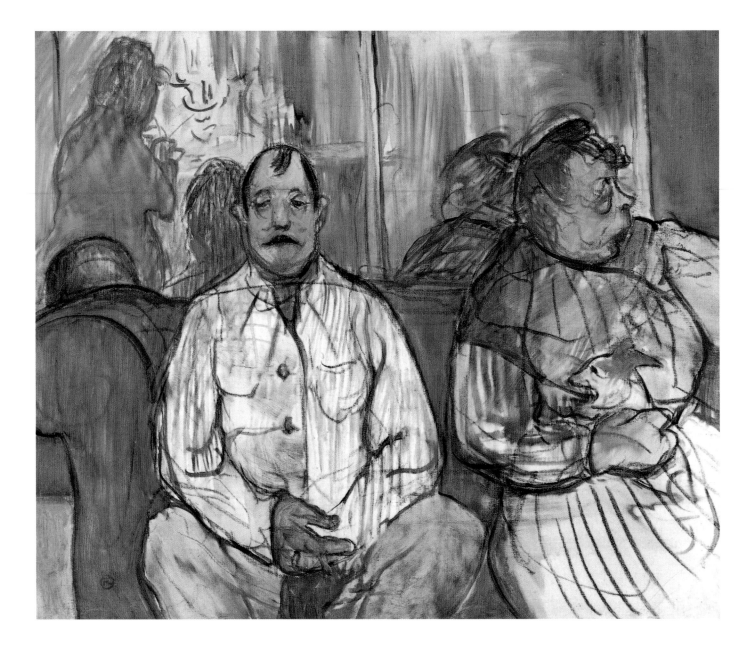

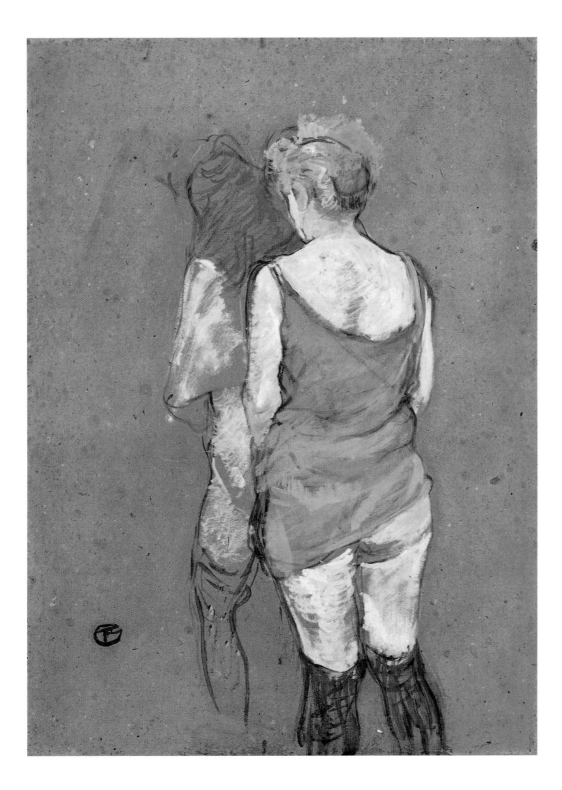

32. **Monsieur, Madame
and the Dog**, 1893.
Black chalk and
oil on canvas,
48 x 60 cm.
Musée Toulouse-
Lautrec, Albi.

33. **Two Half-Nude
Women Seen from
Behind in the rue des
Moulins Brothel**,
1894.
Oil on cardboard,
54 x 39 cm.
Musée Toulouse-
Lautrec, Albi.

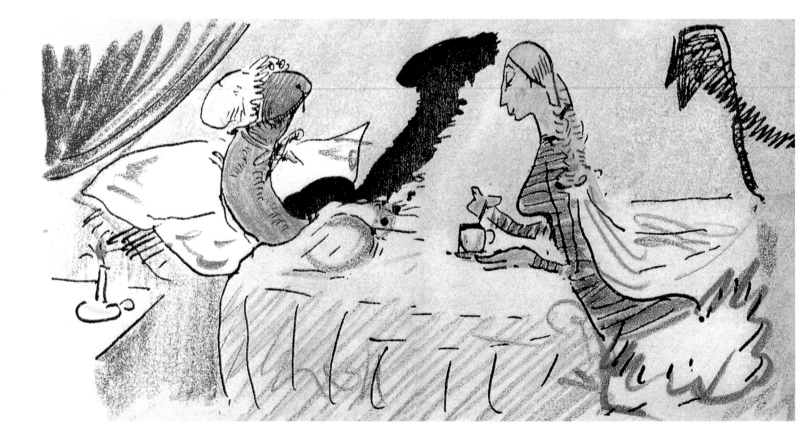

Lautrec's compositional devices, his unusual viewpoints and cropped figures, his trade-mark use of the odd shape of the double bass as a repoussoir silhouetted against the footlights of the stage, his utilisation of diluted oil-paint sometimes mixed with other media, and his insistence on outline all betray Lautrec's close study of the older artist's work. There is also hardly a subject treated by Lautrec - dancers, laundresses, milliners, circus performers, jockeys, cafés, brothels, and so forth - which had not already been explored and opened up by Degas. Degas' approbation of his work meant a great deal to Lautrec. In 1891 he wrote to his mother, 'Degas has encouraged me by saying that my work this summer wasn't too bad.' Lautrec's life-long friend Maurice Joyant described Lautrec 'beaming with inner satisfaction' when Degas remarked 'Well, Lautrec, I see you are one of us,' after seeing Lautrec's exhibition at the Goupil Gallery in 1893. As late as 1898, Lautrec demonstrated his continuing devotion to Degas in a famous and touching incident when he dragged his dinner guests late at night to the house of the Dihau family in order to see Degas' early masterpiece *The Orchestra of the Opera* 'as a dessert'.

Despite his encouraging words, it seems that Degas did not in fact reciprocate Lautrec's admiration. He discouraged a collector from buying Lautrec's work, saying, 'Lautrec has a great talent, but he's merely a painter of the period. He will be the Gavarni of his time.' It is significant that Degas failed to buy a single work by Lautrec for his own collection, although he bought those of other, younger artists such as Cézanne, Gauguin and van Gogh. It may well have been that Degas found Lautrec's work derivative and too close to his own.

Whereas Degas' approach to his working-class female subjects is coldly analytical, like that of a scientist studying the habits, body language and gestures of alien creatures, Lautrec is intensely engaged with his as individual human beings with thoughts and feelings. Lautrec's *Dancer Adjusting Her Tights: The First Pair of Tights* of 1890 (p.32) is clearly indebted to Degas' sculpture of the *Little Dancer Aged Fourteen*. Degas' *Little Dancer* is characterised with a harsh realism that shocked his contemporaries, while Lautrec's ganglingly awkward girl trying on her new costume is treated with a gentleness that borders on the sentimental. Interesting comparisons between Degas and Lautrec can also be made in their treatment of the theme of the *Toilette*.

In the 1880s, Degas pioneered an entirely new approach to the time-honoured subject of the female nude by showing women absorbed in their daily ablutions and personal hygiene, apparently unaware of being observed.

34. ***The Good Girl**: she brings a tisane to her flu-ridden but not shapeless father.*

35. ***In Bed***, 1892.
Oil on cardboard,
64 x 59 cm.
Musée d'Orsay, Paris.

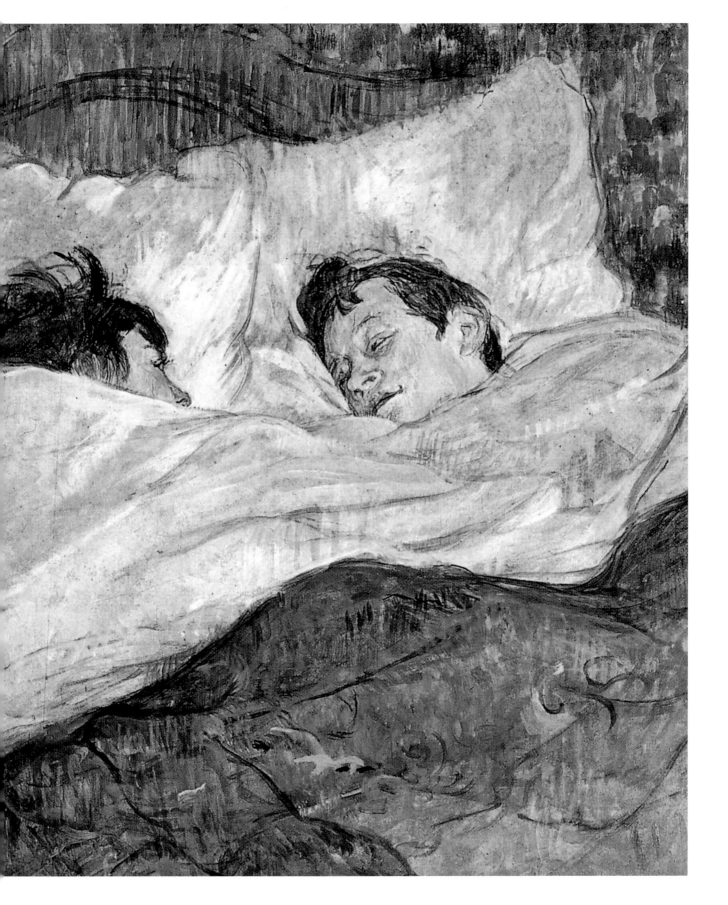

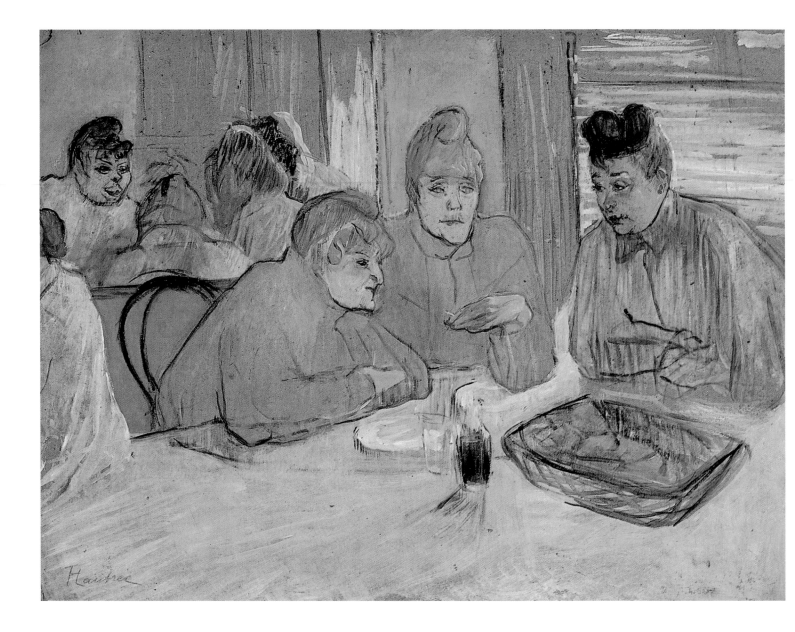

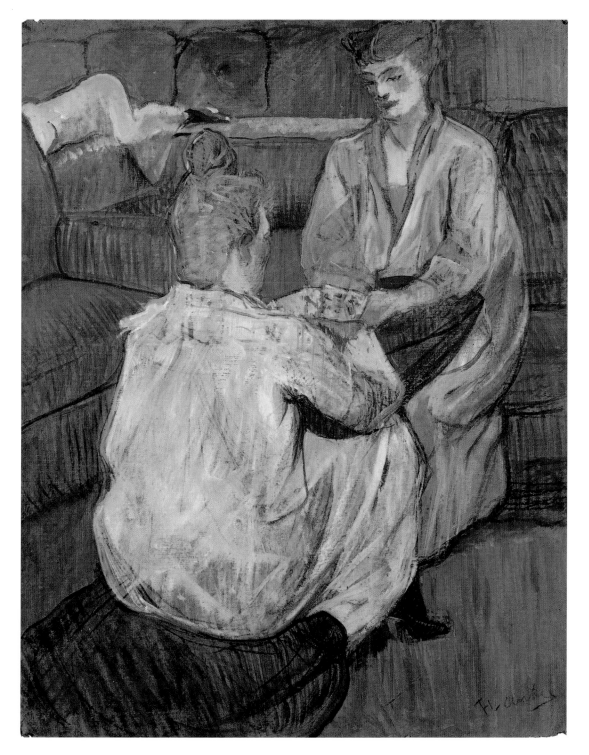

36. **The Ladies in the Refectory**, 1893.
Oil on cardboard,
60.3 x 80.3 cm.
Szépmüvészeti
Mùzeum, Budapest.

37. **The Game of Cards,**
ca. 1893.
Private Collection.

Degas avoids engaging with the individual human being by showing the women from behind or with their faces blurred or hidden. Even when Lautrec follows the same devices, he manages to invest a naked back or a foreshortened cleavage with character and humanity. Lautrec always tends to particularise the human form whereas Degas in the classical tradition tends to generalise.

Degas and Lautrec are the two great poets of the brothel. Degas explored the theme in the late 1870s in a series of monotype prints that are among his most remarkable and personal works. He depicts the somewhat ungainly posturings of the prostitutes and their clients with a human warmth and a satirical humour that brings these prints closer to the art of Lautrec than anything else by Degas. Even here, though, Degas' squat-proportioned prostitutes are types rather than individuals.

Published in 1883, a book that described itself as a 'Directory and Guide to Pleasure for Visitors to the City of Gaiety' lists ninety-nine brothels in central Paris and another eleven in the suburbs. Lautrec's favourite brothel in the Rue des Moulins is described thus: 'A very curious old mansion, a relic of ancient times. It has recently been restored at great expense and electric lighting has been installed there. Possesses a bold entrance, where rich clients enter with their carriages, thus ensuring perfect secrecy. Is much frequented during the daytime.' Photographs taken at the time show plump, smiling prostitutes in various states of dress and undress, and sumptuously decorated interiors. There was a 'gothic' torture chamber, and rooms in the Moorish, Chinese and Baroque styles. The photographs also show extensive plate-mirror glass which, like the electric lighting, was an innovation of the nineteenth century.

*38. **At the Salon in the rue des Moulins**, 1894.*
Black chalk and oil on canvas, 115.5 x 132.5 cm. Musée Toulouse-Lautrec, Albi.

Lautrec used regularly to visit number 24 in the rue des Moulins and other brothels like other more respectable gentlemen might regularly visit health resorts and seaside guest-houses. He would pack up his baggage and move into a brothel for weeks at a time, even handing out his address as that of the brothel to acquaintances such as Yvette Guilbert. Her prudish reaction seems a little hypocritical in a performer whose most famous song, *Le Fiacre*, describes an act of adultery in the back of a horse-drawn cab. Once ensconced in a brothel, Lautrec looked around him with a benign and gently satirical eye. The savagery of his early sketch *Artillery Man and Girl*, which looks forward to the 'New Realism' of the Weimar Republic, was exceptional. More typical is the indulgent humour of *Monsieur, Madame and the Dog* (p.38).

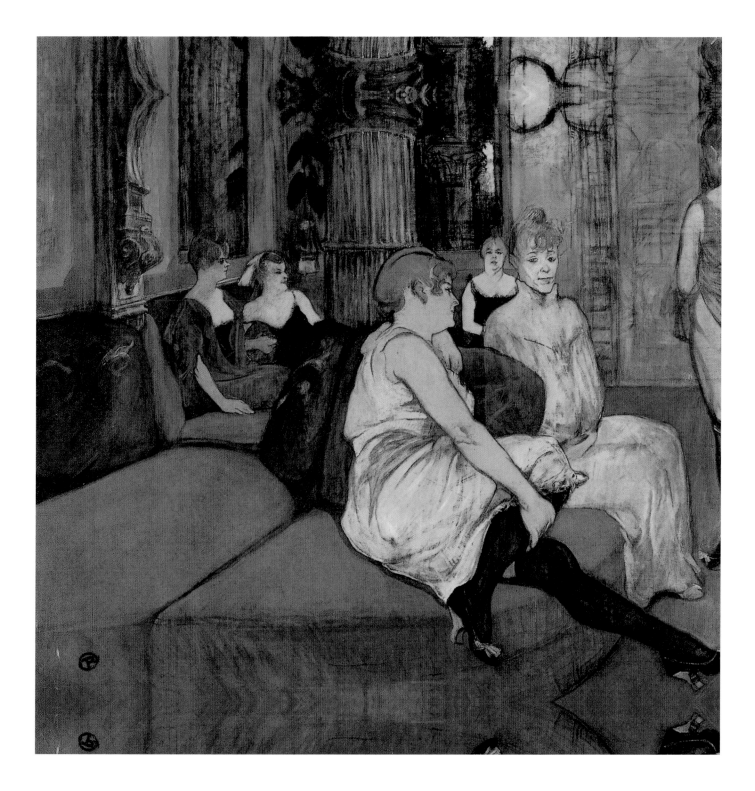

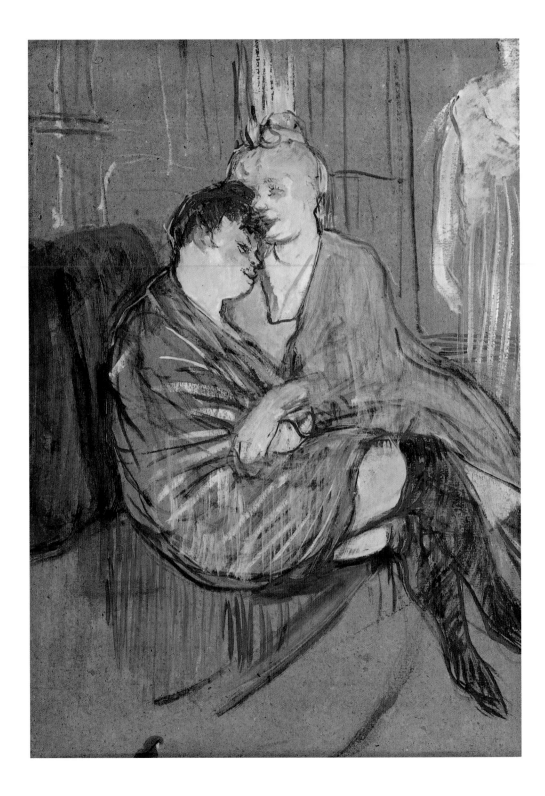

39. **_The Two Friends_**,
1894.
Oil on cardboard,
48 x 34.5 cm.
Musée Toulouse-
Lautrec, Albi.

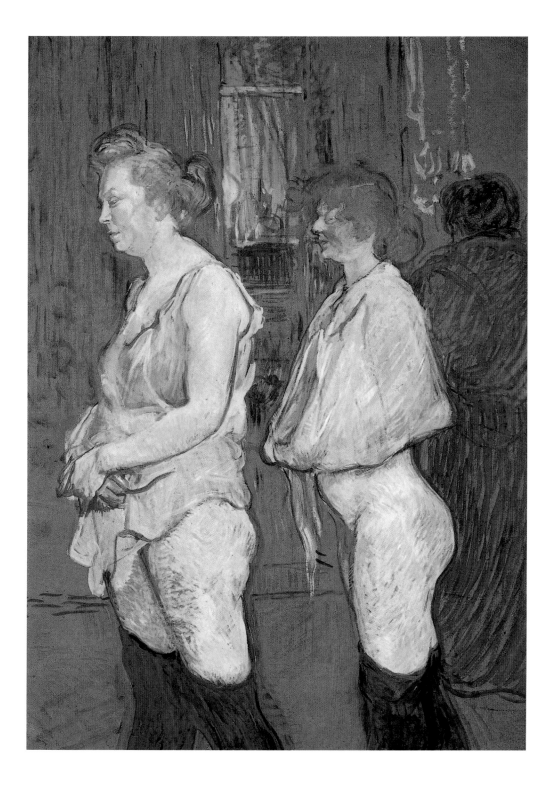

40. *Rue des Moulins: The Medical Inspection*, 1894.
Oil on cardboard, 82 x 59.5 cm.
Chester Dale Collection, National Gallery of Art, Washington (DC).

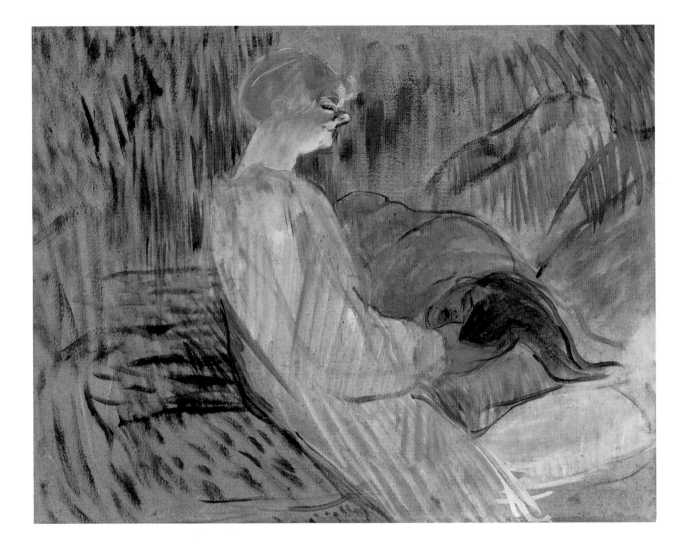

41. ***The Divan, Rolande***,
1895.
Oil on cardboard,
51.7 x 66.9 cm.
Musée Toulouse-
Lautrec, Albi.

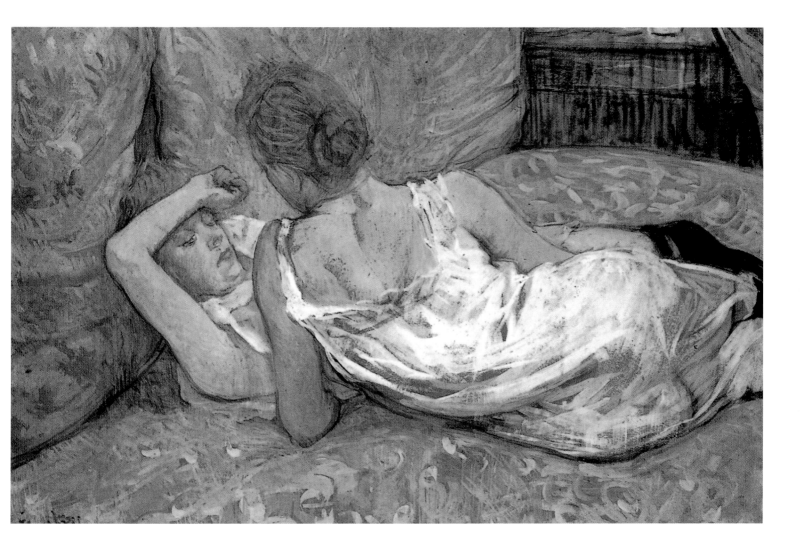

42. ***Devotion: The Two Girlfriends***, 1895.
Oil on cardboard,
45.5 x 67.5 cm.
Private Collection.

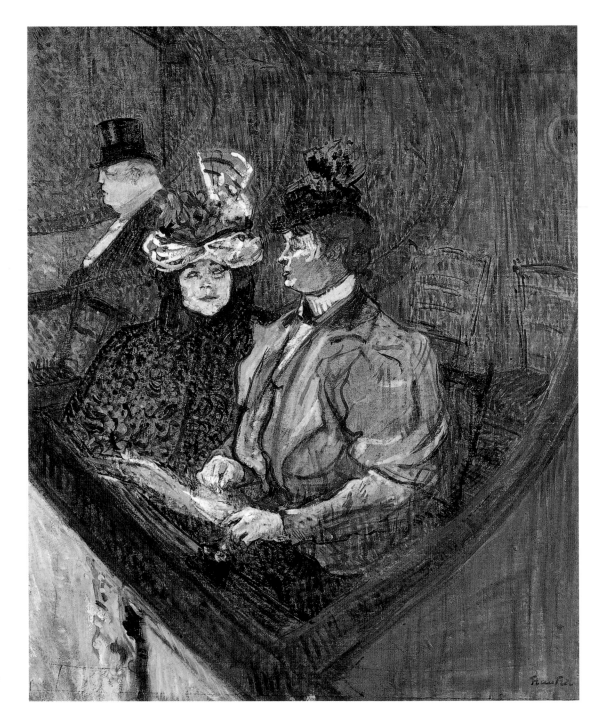

43. *The Grand Box*,
 1896.
 Oil and gouache on
 cardboard,
 55.5 x 47.5 cm.
 Private Collection.

44. *At the Moulin Rouge:
 The Dance*, 1890.
 Oil on canvas,
 115.5 x 150 cm.
 Philadelphia Museum
 of Art, Philadelphia.

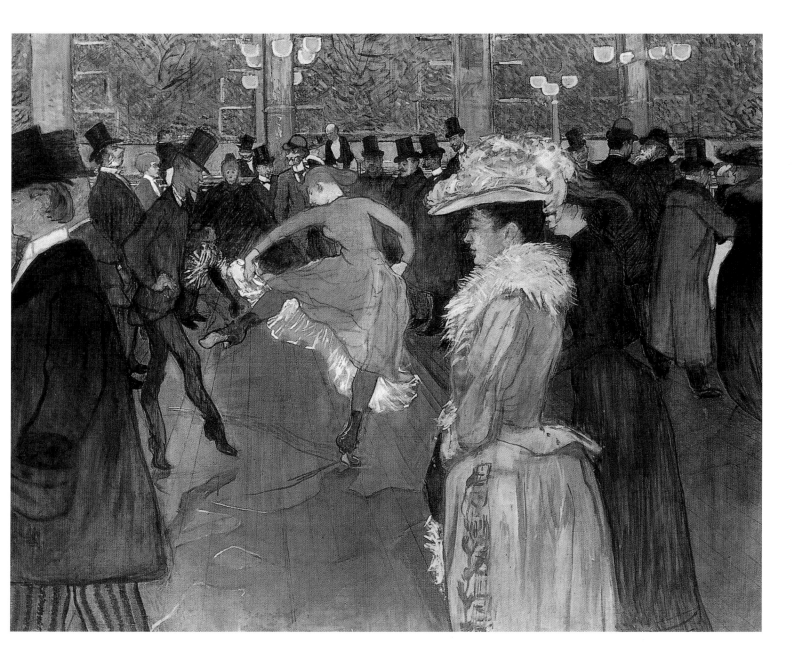

At first glance it seems to be a portrait of a middle-aged petit-bourgeois couple of irreproachable rectitude - but the plate-glass mirror behind the sofa on which they sit with their lap dog shows that they are in fact proprietors of a brothel. The ironic tone of this picture is reminiscent of Degas' *Madame's Name-Day*, in which the stout madame of the brothel is dressed in black like a respectably grieving widow. Lautrec observed the daily routine of the brothel without the slightest hint of the sensational or the prurient. The prostitutes are depicted in shapeless dressing-gowns, killing time between clients by playing cards or huddled round the breakfast table.

In Lautrec's ambitious and monumental painting of a brothel *At the Salon in the Rue des Moulins* of 1894 (p.47), the atmosphere is solemn and joyless. The colloquial term *filles de joie* seems singularly inappropriate. The prostitutes loll in attitudes of boredom on plushly upholstered divans under the watchful eye of the severe-looking madame. On the right, we glimpse the half-seen figure of a prostitute lifting her skirts to display what she has to sell to prospective clients. In raising her skirts this woman is as matter-of-fact as the sad women obliged to expose their private parts in Lautrec's grim painting of a medical inspection.

The ordeal of the medical inspection was regularly undergone by all residents of legalised brothels, in the interests of public health and in a vain attempt to stem the ravages of syphilis - a disease that Lautrec himself contracted and that together with his excessive drinking contributed to his early death. This terrible disease first appeared in Europe in the 1490s, in Naples, most probably introduced from America by the sailors of Columbus.

After the French troops of Charles VIII sacked Naples in 1495, they spread the disease throughout Europe, resulting in its reputation over much of the continent as the 'French pox'. Syphilis soon reached high places. Francis I of France, Henry VIII of England and Michelangelo's patron Pope Julius II are believed to have been among its early victims. As a result of social and economic changes, syphilis spread with new virulence in the nineteenth century, cutting a terrible swathe through nineteenth-century French culture. Edmond de Goncourt, the great chronicler of nineteenth-century Paris, described in his diaries the devastating impact of the disease upon his brother Jules as he declined into paralysis, insanity and death, and also the terrible agonies suffered by the writer Alphonse Daudet.

45. *Woman at the Bath Tub, from the "Elle" Album*, 1896. Coloured lithograph, 40 x 52.5 cm. Private Collection.

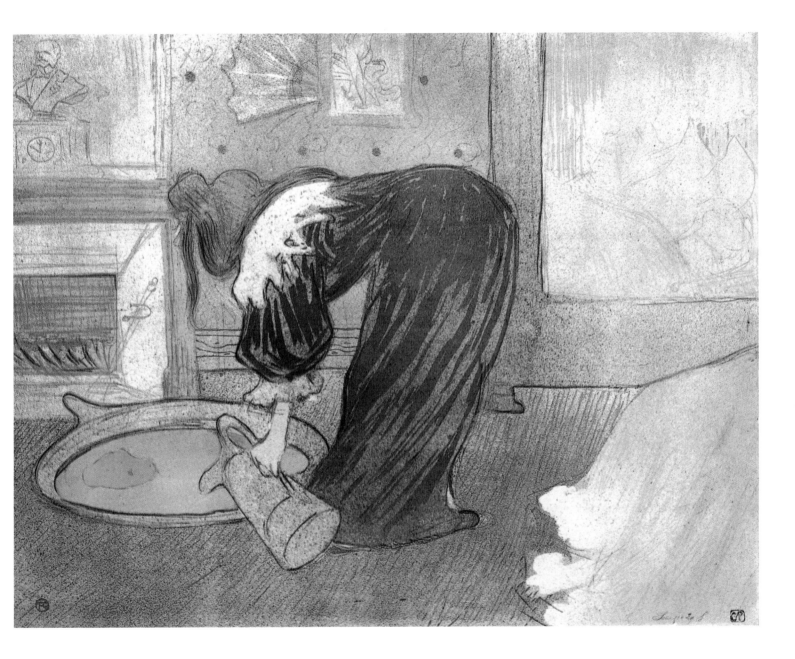

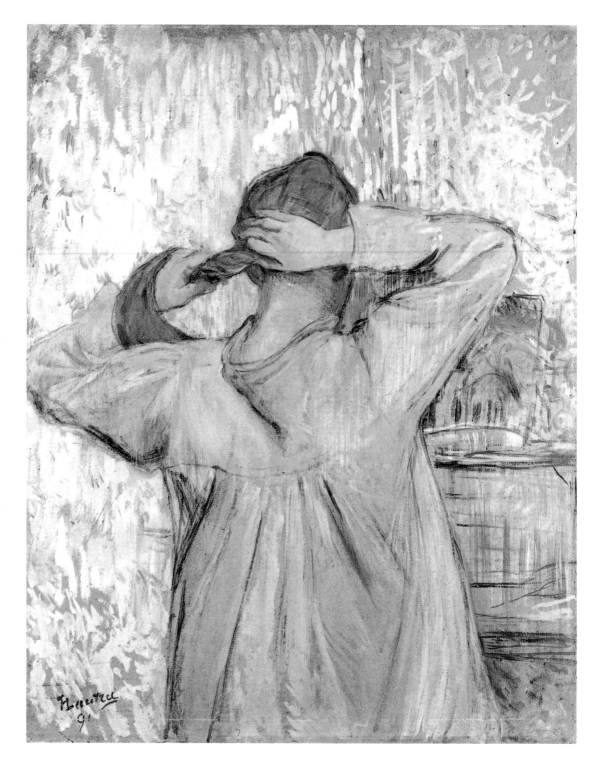

46. *Woman Combing her Hair, "Elle"*, 1891.
Oil on cardboard,
58 x 46 cm.
The Ashmolean
Museum, Oxford.

47. *Woman Putting on her Corset: Passing Conquest*, 1896.
Black chalk and
oil on silk,
104 x 66 cm.
Musée des Augustins,
Toulouse.

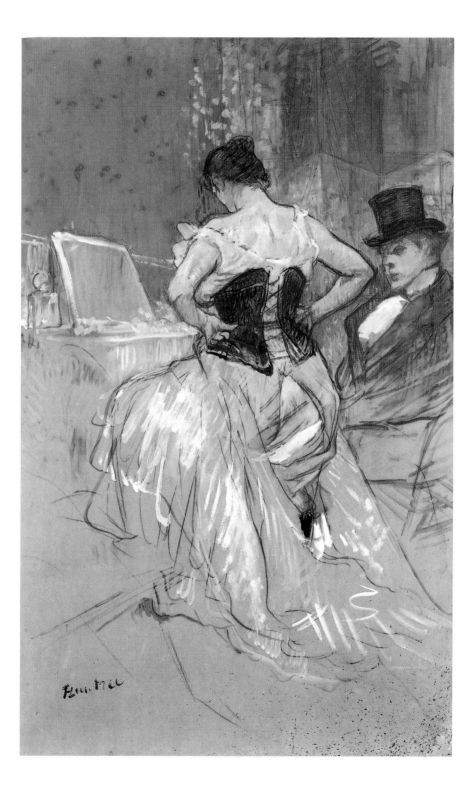

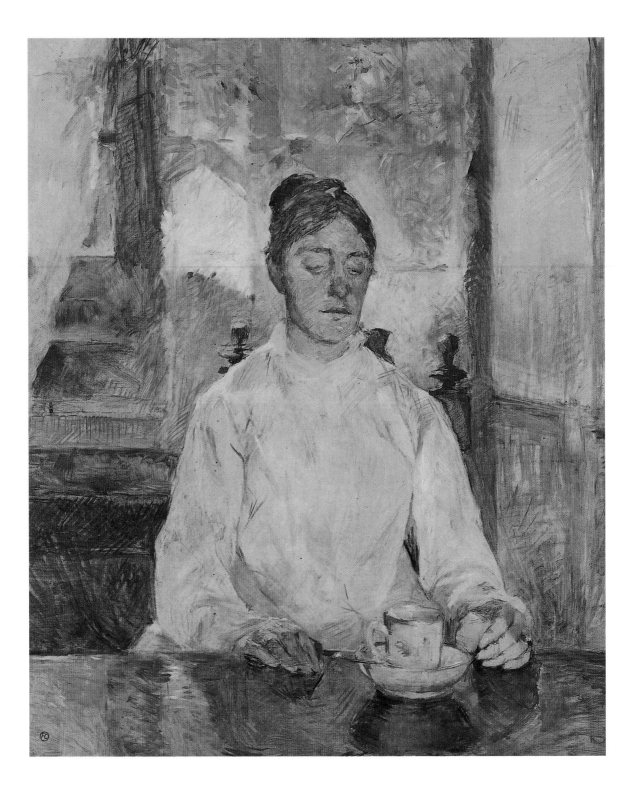

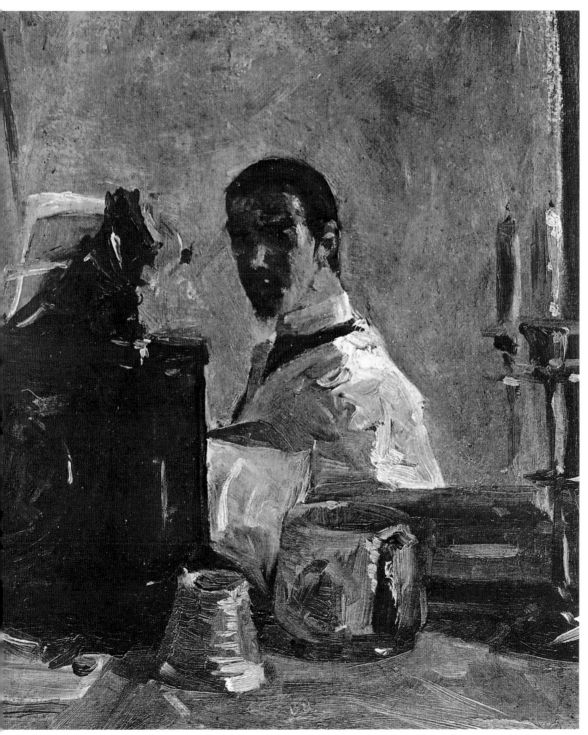

48. ***The Artist's Mother,
Countess Adèle de
Toulouse-Lautrec,
Breakfast at Château
Malromé***, 1881-1883.
Oil on canvas,
93.5 x 81 cm.
Musée Toulouse-
Lautrec, Albi.

49. ***Self-Portrait in a
Mirror***, ca. 1880.
Oil on cardboard,
40.3 x 32.4 cm.
Musée Toulouse-
Lautrec, Albi.

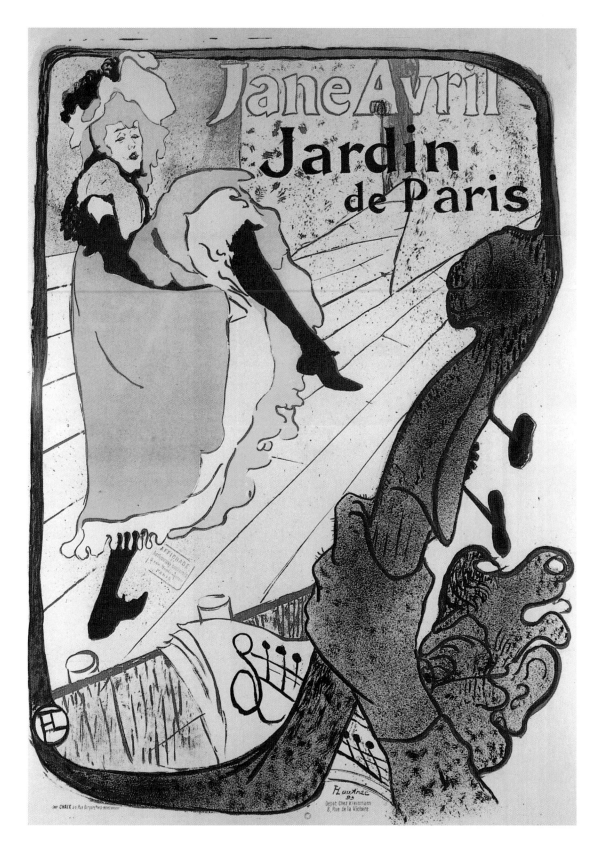

50. *Jane Avril in the
Paris Garden*, 1893.
Colour lithograph,
poster,
130 x 95 cm.
Private Collection.

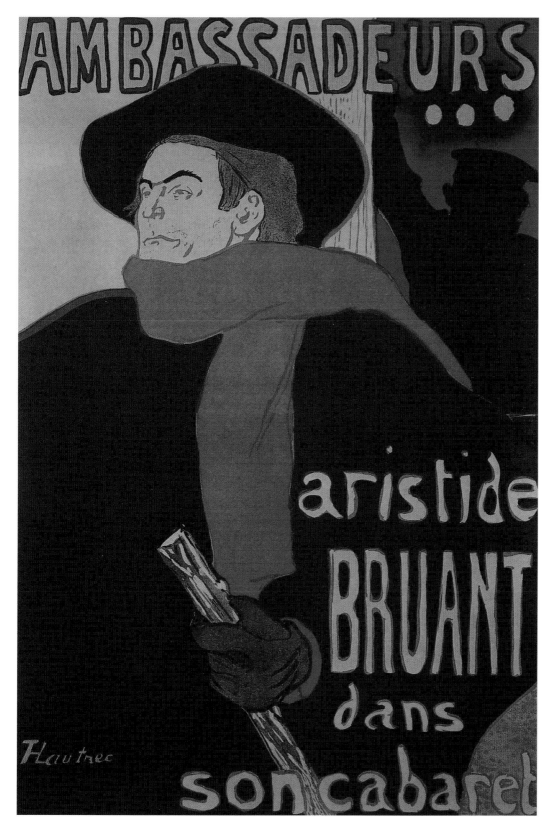

51. *Aristide Bruant in his Cabaret*, ca. 1892.
Colour lithograph,
poster,
150 x 100 cm.
Private Collection.

Among the French writers and artists who died of syphilis were Baudelaire, Manet, Guy de Maupassant and Gauguin. So distinguished was the list of victims that contracting syphilis acquired a certain cachet.

In 1877, Guy de Maupassant made his announcement that he had caught the disease with chilling bravado: 'For five weeks I have been taking mercury and potassium iodine, and I feel very well on it. My hair is beginning to grow again, and the hair on my arse is sprouting. I've got the pox! At last! Not the contemptible clap - no, no - the great pox. The one Francis I died of. The pox of kings. And I'm proud of it, by thunder. I don't have to worry about the street whores and trollops, and afterwards I say to them, 'I've got the pox.'' It was perhaps almost inevitable that he should die from syphilis, so becoming a 'dead French pervert' . . . and being acknowledged by his country as a genius.

Many of Lautrec's brothel images show prostitutes embracing or in bed with one another. The theme of lesbianism had preoccupied many French writers and artists since the middle of the nineteenth century, and the kind of nineteenth-century male voluptuary who was attracted to Paris in search of sexual adventure often took a prurient interest in lesbianism. So it was that the belief - with or without any factual basis - emerged that most Parisian prostitutes indulged in promiscuous lesbian sex.

This finds expression in sexual guides to the city such as *The Pretty Women of Paris*, published in 1883. In this book we are told, for example, of the prostitute Francine de Sancey that what she really enjoys is to fall upon the genital organs of one of her own sex, and that thanks to the tribadic tastes of most of her fellow-workers she is hardly ever without a Sapphic consort. When Lautrec shows lesbian couples out on the town, as he does in the prints *The Foyer, The Grand Box* (p.52) and *At the Moulin Rouge: The Dance* (p.53), he depicts them as mannish and predatory, with the fierce mask-like faces he also gives to his stage performers. Within the cloistered confines of the brothel, however, it is quite a different matter. His images of prostitutes embracing or caressing are not really about sex at all, but about affection and about human beings comforting one another. They could not be more different from the lubricious scenes of lesbian love painted by Courbet. Despite the several occasions on which Lautrec had himself photographed in what appears to be female costume, there can be little doubt about his heterosexuality.

52. *Japanese Divan*,
ca. 1892-1893.
Colour lithograph,
poster,
80.8 x 60.8 cm.
Private Collection.

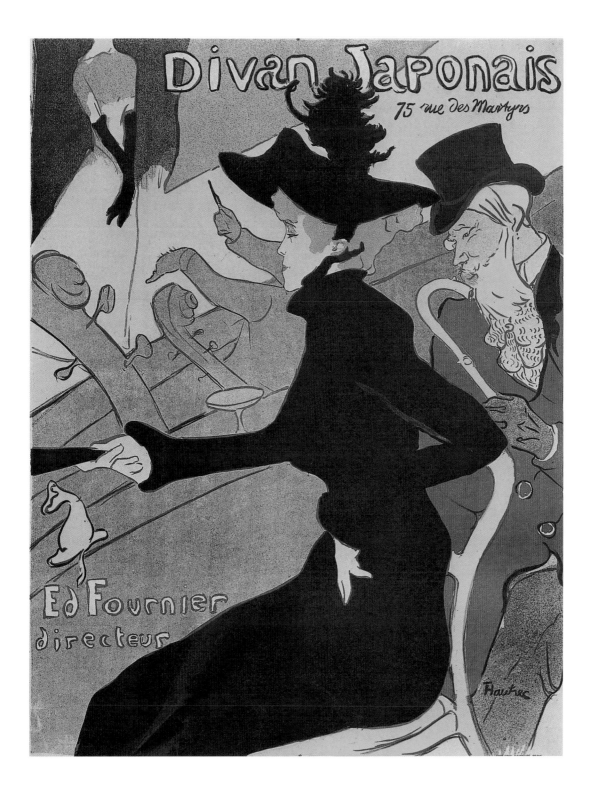

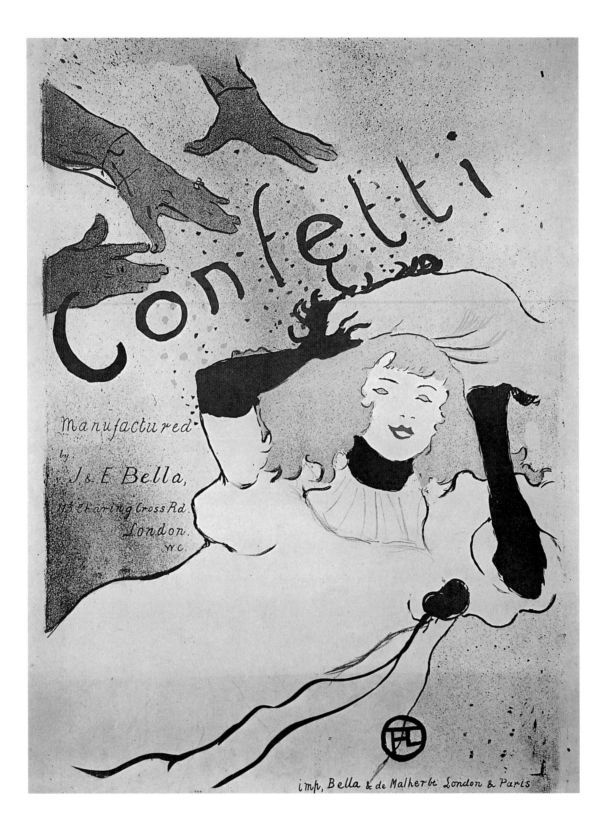

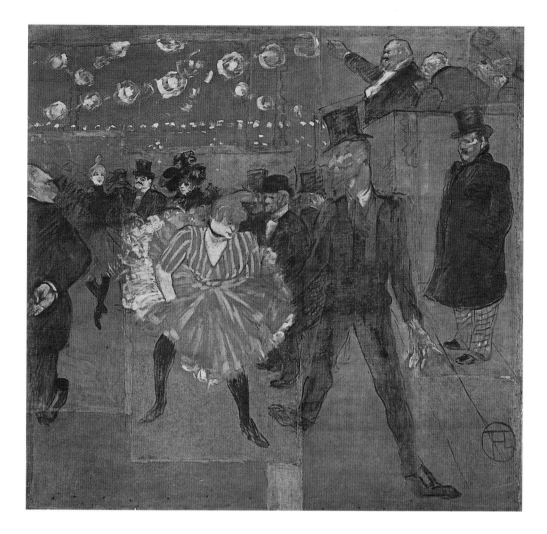

However, his own sense of 'otherness' resulting from his physical appearance and infirmities gave him a strong empathy with those who would have been regarded by many of his contemporaries as deviants. He was clearly fascinated by Oscar Wilde, on one of his periodical visits to London in 1895 even attending some sessions of the author's trial for homosexual offences and making several portraits of Wilde's bloated and androgynous face.

Lautrec's art reached a peak in 1896 with the series of eleven lithographs (including the cover) entitled *Elles* depicting scenes of daily life in a brothel. The series provides a splendid coda to Lautrec's interest in the subject in the first half of the 1890s and, indeed, to the interest in Parisian 'modern life' subjects that had prevailed among French artists and writers since the 1860s.

53. ***Confetti***, 1894.
Colour lithograph,
poster,
54.5 x 39 cm.
Private Collection.

54. ***La Goulue Dancing with Valentin-le-Désossé***, 1895.
Oil on canvas,
298 x 316 cm.
Musée d'Orsay, Paris.

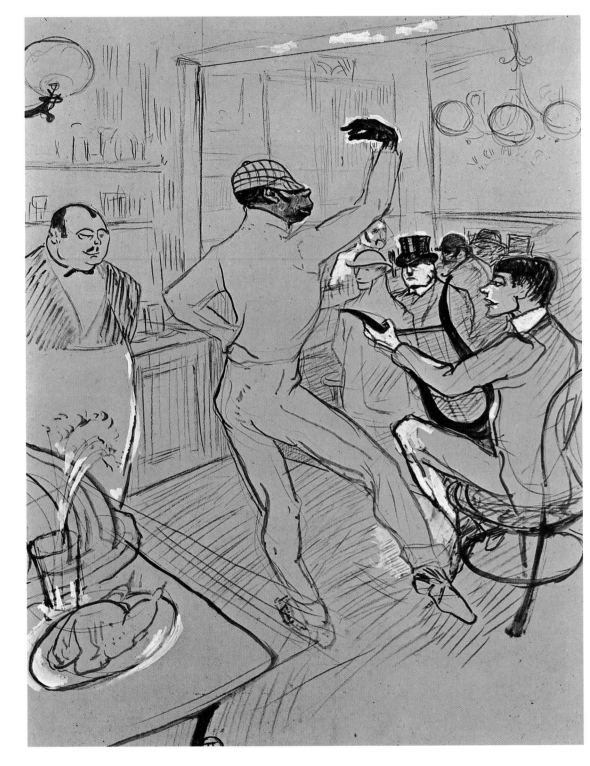

55. ***Chocolat Dancing at the "Bar Irlandais et Américain"***, 1896.
Chinese ink, pencil and watercolour on paper,
65 x 50 cm.
Musée Toulouse-Lautrec, Albi.

56. ***The Actor Henry Samary***, 1889.
Oil on cardboard,
75 x 52 cm.
Musée d'Orsay, Paris.

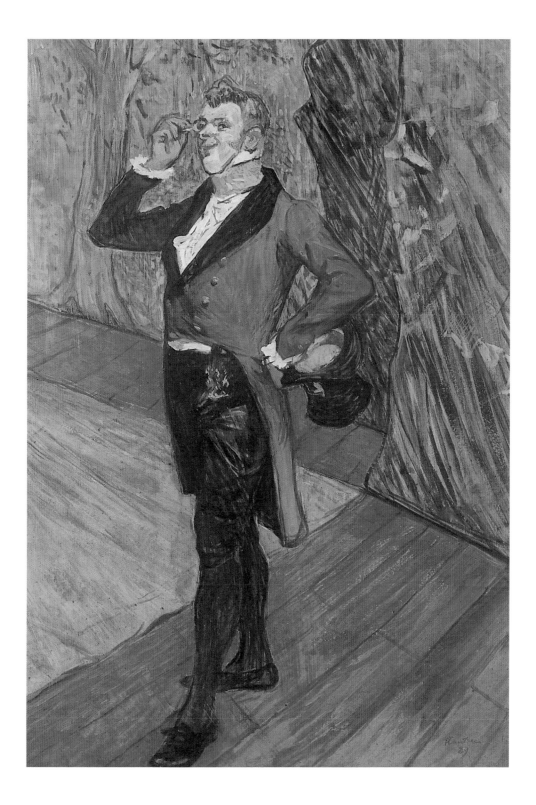

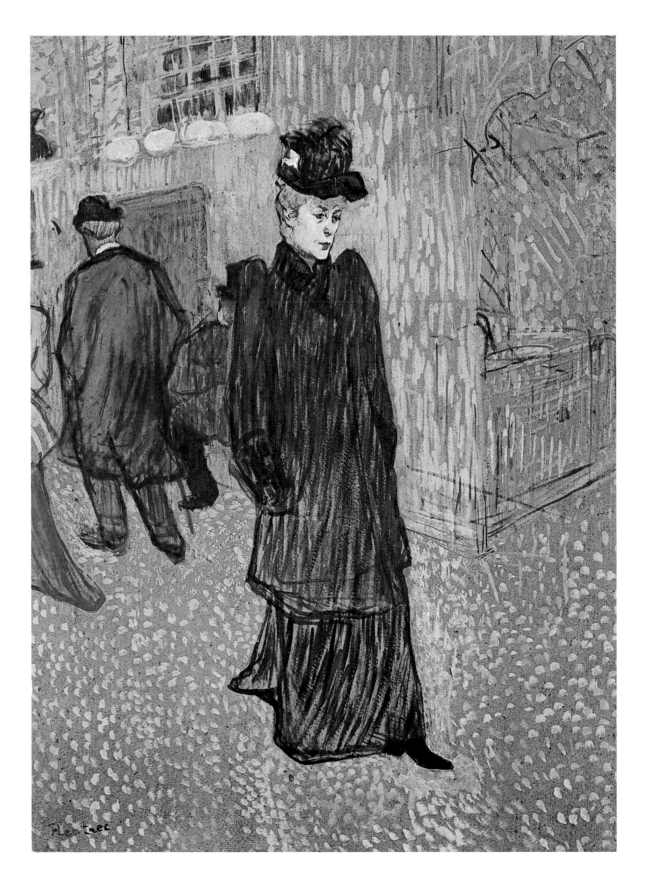

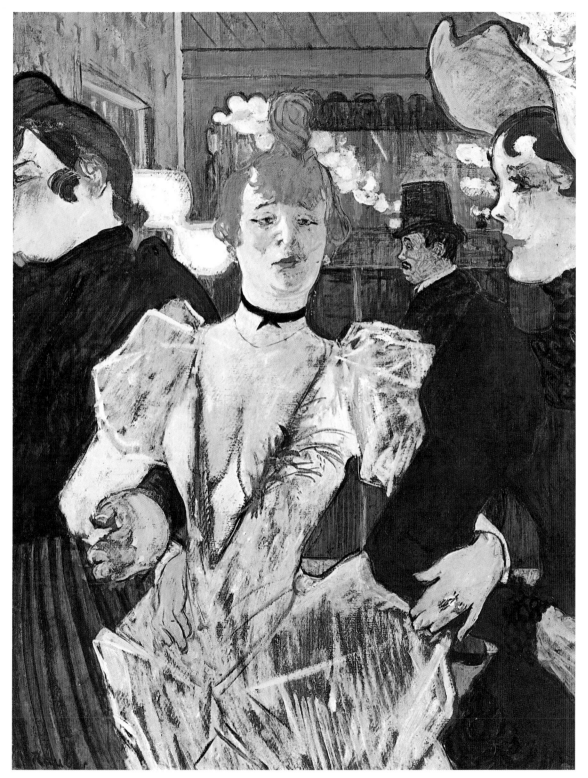

57. ***Jane Avril Leaving
the Moulin Rouge***,
1893.
Oil and gouache on
cardboard,
79.4 x 59 cm.
Wadsworth
Atheneum, Hartford.

58. ***La Goulue Entering
the Moulin Rouge
with Two Women***,
1892.
Oil on cardboard,
79.4 x 59 cm.
Museum of Modern
Art, New York.

The title *Elles* (perhaps best translated as 'Those Women'), as announced boldly on the cover, expresses the otherness of these ladies who, as Zola put it, 'cast off their decency with their clothes'.

Seen from behind, *Elle* or 'the Woman' of the cover lifts her long flowing hair with a voluptuous gesture. At this time when 'respectable' women were never seen in public with their hair down, the very sight of unbound hair conveyed an erotic frisson. On the left, the client's top hat is perched suggestively on top of a pile of discarded feminine clothes and leaning towards the girl. The black top hat was part of the 'uniform' worn by every nineteenth-century middle-class male (and of 'undertaker's mutes', as Baudelaire pointed out).

Courbet, Manet, and in particular Degas, had all exploited the top hat as a symbol of masculinity and bourgeois morality. Lautrec's use of the hat here may be specifically inspired by a picture by Gervex entitled *Rolla* that gained great notoriety when it was rejected on moral grounds from the Salon. In this picture, Gervex also featured a cylindrical top hat jutting out suggestively from a pile of frothy, feminine underwear, apparently torn off and thrown down in a frenzy of lust. The fifth and seventh sheets of *Elles*, which show a *Toilette* and a *Woman Combing Her Hair* (p.56), are the most dependent on Degas. As mentioned earlier, though, Lautrec explores and maps out the creases, lumps and bumps of the sagging flesh with the dogged truthfulness of the northern Renaissance masters.

The sixth of the series, *Woman Looking Into a Mirror Held in Her Hand*, is reminiscent of the traditional iconography of the *Vanitas*. Despite the piquant and homely details of the underwear, the rumpled bed and the neatly-placed slippers, the image has a dignity that might seem at odds with the brothel subject matter. *Woman Fastening a Corset: Passing Conquest* (p.57) is dependent upon another keywork of 'modern life' painting: Manet's *Nana* of 1877.

59. **Laundress**, 1884.
Oil on canvas,
93 x 75 cm.
Private Collection,
Paris.

Lautrec would have had every opportunity to study Manet's work in 1894, when he exhibited at the Durand-Ruel Gallery at the same time as a major Manet retrospective. Manet had taken the character of Nana from Zola's novel *L'Assommoir*.
Nana, who is no more than a very minor character in *L'Assommoir*, is shown as she was later to be in a scene from Zola's next novel *Nana*, getting dressed in front of her besotted middle-aged lover Count Muffat.

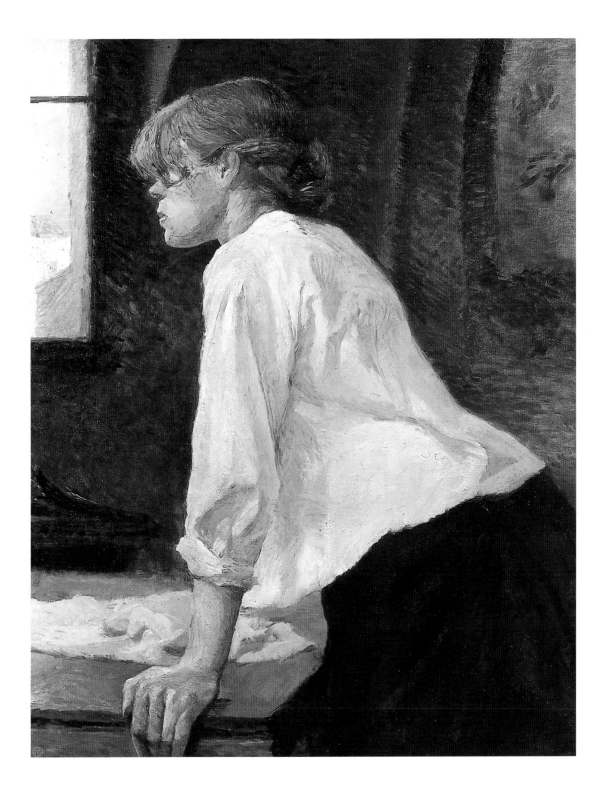

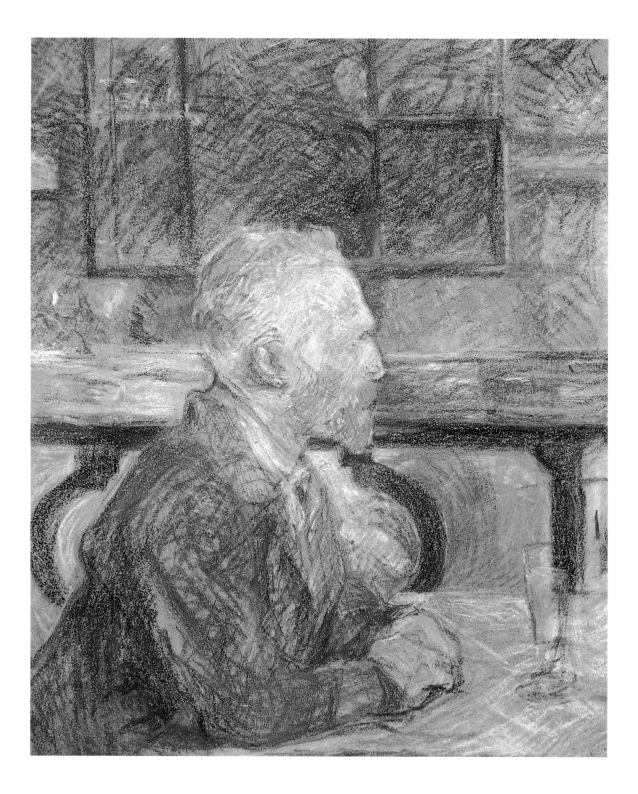

It seems that Manet's painting inspired certain details of the scene as eventually described by Zola, in a telling example of the symbiotic relationship between painting and literature in nineteenth-century France. Lautrec makes a characteristically cynical comment on the nature of this 'passing conquest' in the little picture that hangs on the wall to the left, which shows a lecherous satyr groping a naked woman.

The poignant images of the second and eighth sheets in the series, entitled *Woman with a Tray, Breakfast, Madame Baron and Mademoiselle Popo* and *Woman in Bed, Profile: Getting Up*, could both be subtitled 'The Ages of Women'. The two of them show the young prostitute Paulette Baron (Mademoiselle Popo) and her mother Juliette Baron, now too old to be in demand as a prostitute and employed instead by the brothel as a servant.

The happiest and most delightful of the series is the third, entitled *Woman Waking Up in Bed*. Only the upper part of one side of her face and a limph are visible of this young woman who indulges in the early morning warmth and comfort of her bed.
The mood of this image is in marked contrast to that of the final print in the series, *Woman Lying on Her Back: Lassitude*, which shows a woman exhausted at the end of a hard day's or night's work, lying open-legged across her bed.

Produced at the same time as *Elles* but separate from the series is the lithograph *Sleep*. A naked woman lies in bed exposing the upper half of her torso. She is depicted with an outright and unabashed sensuality that is rare in Lautrec's work. The truthfulness with which Lautrec portrayed aspects of life that most of his more respectable contemporaries preferred to sweep under the carpet naturally caused offence. The German critic Gensel probably spoke for many when he wrote, 'There can of course be no talk of admiration for someone who is the master of the representation of all that is base and perverse. The only explanation as to how such filth - there can be no milder term for it - as *Elles* can be publicly exhibited without an outcry of indignation's being heard is that one half of the general public does not understand the meaning of this cycle at all and the other is ashamed of admitting that it does understand it.'

Lautrec deals with almost every aspect of human sexuality with unflinching truthfulness, occasionally with savage humour, but more often with a gentleness and humanity that removes his art to the farthest extreme from brutalising pornography.

60. ***Portrait of Vincent van Gogh,*** 1887. Pastel on cardboard, 54 x 45 cm. Rijksmuseum, Amsterdam.

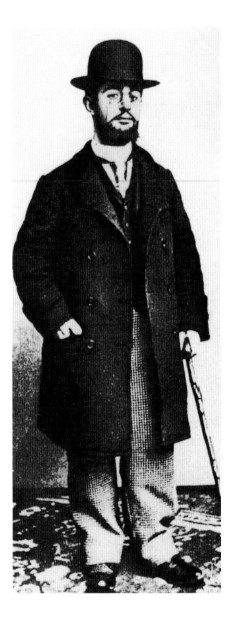

BIOGRAPHY

1864:

Birth of Henri Marie Raymond de Toulouse-Lautrec-Monfa on November 24th in Albi.

He spends his early childhood pampered by his family.

1868:

His one-year old brother dies and his parents separate. A nanny takes care of Henri

from now on.

1872:

At the age of eight, he leaves to live with his mother in Paris. He draws his first sketches

and caricatures on his exercise workbooks. He then takes lessons from the painter René

Pierre Charles Princeteau, a friend of his father.

1875:

Returns to Albi for health reasons. He takes thermal baths at Amélie-les-Bains and his

mother consults with many doctors in the hopes of finding a way to improve her son's

growth and development.

1879:

After two fractures, due to a congenital anomaly, his legs stop growing.

1880:

He does many drawings while in Albi, encouraged by his uncle Charles. During 1874,

Henri executed more than 2,400 drawings using multiple techniques.

61. Toulouse-Lautrec in
1892, Photograph.

1881:

After failing a first time in July while in Paris, Henri passes the first part of his college entrance exam in October in Toulouse and finishs his studies. During his stay in Nice, he achieves a number of paintings and drawings. René Princeteau convinces Henri's parents to let him study painting in Paris with Bonnat.

1882:

He begins to study at Bonnat's workshop, a triumphant artist at the time. Bonnat, an aesthete, was a cold, academic painter and a tyrannical teacher. He did not hold a very high opinion of Henri. The workshop soon closed and Henri went to study with Cormon where he met Emile Bernard and van Gogh. He criticized the work of Cormon, saying that it was not highly innovative, but nevertheless appreciated the artist's teaching technique. He was to stay in Cormon's workshop for five years.

1884:

He moves into a workshop in Montmartre and finds his models in the places of pleasure in the quarter. He meets Aristide Bruant, who influences him for many years to come. The singer shows some of Henri's first works at the cabaret *Le Mirliton* and his drawings are reproduced in a journal of the same name.

1887:

In May, he participates in an exposition in Toulouse under the pseudonym "Tréclau", an anagram of the word "Lautrec". He exhibits works in Paris with van Gogh and Anquetin. He studies Japanese prints.

62. *Mister Toulouse paints Mister Lautrec*, 1890. Photomontage.

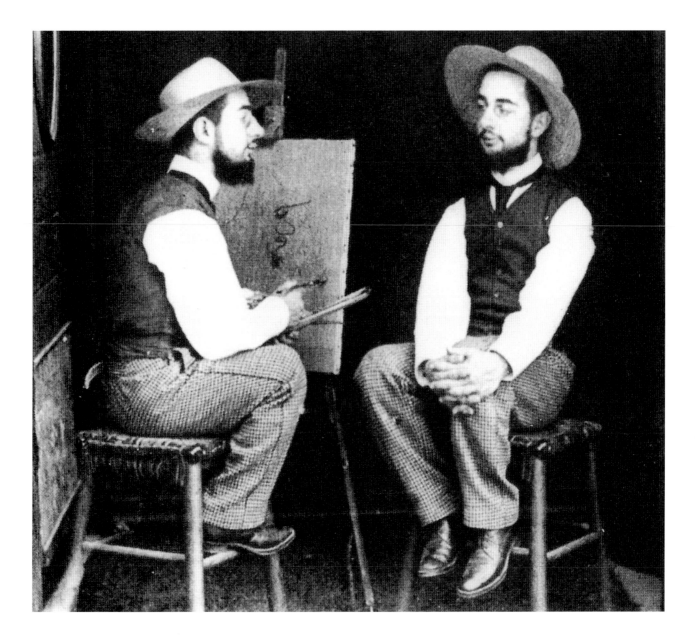

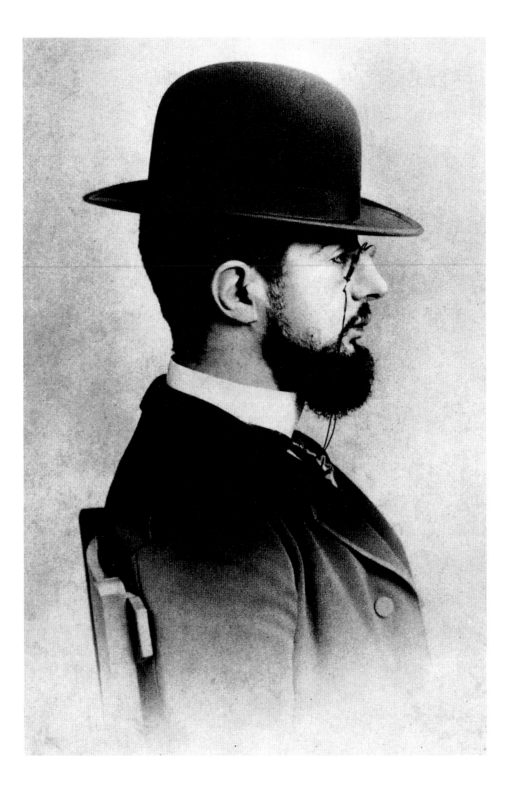

LIST OF ILLUSTRATIONS

1889:

From 1889 until 1894, Henri regularly takes part in the Independent Artists' Salon, the artistic "Circle" and the "Literary Volnay". He does several landscape paintings in Montmartre. As soon as the Moulin Rouge opens on October 5th, he becomes a regular at the famed nightclub and has his own reserved table each night. His paintings are also exhibited at the Moulin Rouge.

1891:

First lithographs and publication of his first poster: *The Moulin Rouge (The Glutton)*.

1893:

First large personal exhibition organized by Joyant. Henri participates in the exhibition "Painters - Engravers" with eleven lithographs.

1894:

He takes a trip to London where he meets Whistler and exhibits several of his posters at the "Royal Aquarium". He does a number of studies, portraits and scenes of houses.

1897:

His health degrades due to his problems with alcohol. He nevertheless continues to paint.

1899:

Publication of the illustration of Jules Renard's *Natural History*. His social drinking is replaced by a severe alcoholism that is much more serious and he is forced to enter into a rehabilitation clinic.

1901:

He returns to be with his mother and dies on September 9th, at the age of 37, surrounded by his family.

63. Toulouse-Lautrec in 1894, Photograph.